P9-CNB-069

 Steinbeck Remembered

Steinbeck Remembered

Interviews with friends
and acquaintances of
John Steinbeck

by Audry Lynch

2000
FITHIAN PRESS
SANTA BARBARA, CALIFORNIA

Copyright © 2000 by Audry Lynch
All rights reserved
Printed in the United States of America

Published by Fithian Press
A division of Daniel and Daniel, Publishers, Inc.
Post Office Box 1525
Santa Barbara, CA 93102
www.danielpublishing.com

LIBRARY OF CONGRESS CATALOGING-IN-PUBLICATION DATA
Lynch, Audry.
 Steinbeck Remembered / by Audry Lynch
 p. cm.
 ISBN 1-56474-326-8 (alk. paper)
 1. Steinbeck, John, 1902–1968. 2. Steinbeck, John, 1902–1968—Friends
and associates. 3. Novelists, American—20th century—Biography. I. Title.
 PS3537.T3234 Z7229 2000
 813'.54—dc21 99-050842

This book is dedicated to my daughter,

Roberta Lynch,

because of the time, support, and technical expertise

she brought to the project. Her camcorder and computer

knowledge were invaluable to the completion of this book.

I value her as a daughter, friend, and colleague.

Contents

Acknowledgements

First of all I would like to thank Mr. John Daniel, my publisher, for his enthusiasm and encouragement of this book. Next I would like to thank Mr. Eric Larson, my editor, for his scrupulous attention to the manuscript both grammatically and for content.

I appreciate greatly the readiness of eminent Steinbeck scholars to read, critique, and comment on the manuscript: Professor Maurice Dunbar, Roy Simmonds, Barnaby Conrad, Professor Kiyoshi Nakayama, Michael Hemp, and Dean Brian Railsbach.

For the gracious and generous use of pictures I am grateful to the following: John Hooper (Steinbeck Center), Eleanor Royal (Valley Guild), Pat Hathaway (California Views), Mary Gale (Salinas High School), Tony Bliss (Bancroft Library, University of California at Berkeley), and Reverend Thomas B. Woodward (St. Paul's Episcopal Church, Salinas).

I also appreciate my husband, Gregory Lynch, for his patience and help during the compilation of the manuscript as well as his computer assistance.

Last, but definitely not least, is my gratitude to my interviewees who gave freely of their time and their memories to make this book possible. I love you all!

Foreword

To many who seem to have a supercilious attitude toward the work of Steinbeck, his readers and scholars have the superficial enthusiasm of groupies. This could hardly be further from the truth. Among the most devoted of the defenders and promoters of this Sage of Salinas are some of the best scholars in the country—Timmermann, Astro, French, Hayman, Hayashi, and too many others to mention. Add the name of Harvard-educated Dr. Audry Lynch. However, Dr. Lynch is not the typical narrowly specialized researcher-writer. It is her very versatility that is impressive. She has taught at virtually every grade level, from elementary school to graduate studies. Her patience with documentary research and talent for the investigative interview are assets to which she adds a lucid style.

If you have the remotest interest in the life and adventures of John Steinbeck, you will cherish this book, read and re-read it. You will enjoy the personal touch and the insight and empathy of the author as well as her integrity. Like Ed Ricketts, Audry loves true things. These are true things.

Maurice Dunbar, Professor Emeritus
English Department
DeAnza College
Cupertino, California

Introduction

One of the most common questions that people ask me is, "How did you get interested in Steinbeck?"

As with all of my Steinbeck involvements, I have to answer truthfully, "By accident." It all started in the 50s, when I was an undergraduate at Harvard University. I started as an English major, but I never discovered his name on any of my reading lists.

My family used to spend their summers on Cape Cod, and I used to pass the time by reading. Once I picked up a copy of *Cannery Row* and was thrilled by the opening lines. To a New England girl, it sounded like a very strange and wonderful place. Then I proceeded to read straight through all of Steinbeck's books— something I had never done before and have never done since with any other author. I was hooked!

Steinbeck's writings left an indelible mark on my mind, but the interest remained dormant until 1970, when my husband was transferred to California. Instead of thinking, "I'm going to California," I thought to myself, "I'm going to Steinbeck Country." I didn't know exactly what that would entail, but I knew that I wanted to explore the country that Steinbeck had written about so well.

In 1971 I had an opportunity to do just that. Dr. Martha Cox, a professor at San Jose State University and one of the earliest and most prominent Steinbeck scholars, organized a weekend Steinbeck conference in Monterey. Gwen Steinbeck, his second wife, joined us for the trip. I met and spoke with Steinbeck's classmates and friends. For the first time a "dead" author (Steinbeck had passed away in 1968) suddenly became "alive" for me.

Then my interest, like Topsy, "just growed." I kept reading and researching until my accumulated Steinbeck lore needed an outlet. I proposed teaching a class on Steinbeck for Metropolitan Adult Education in San Jose. That led to teaching courses at area community colleges, lectures to groups ranging from schoolchildren to seniors, and, finally, to leading my own tours to Steinbeck Country. After purchasing a first-edition copy of *Cup of Gold*, I joined the ranks of avid Steinbeck collectors. This broadened my sphere of Steinbeck enthusiasts and gave my travels a new focus as my collecting extended itself into foreign editions. Finally, I wrote a book with "Sparky" Enea about the famous expedition to the Sea of Cortez.

Throughout all these activities, like most people, I didn't recognize the value of what was right in my own back yard. It didn't really register on me until old friends of Steinbeck, whom I also counted as my friends, began to pass away. One of the houses Steinbeck had lived in was right in my own town, and another was in the next town. His first wife, Carol, had been a San Jose girl. It was all around me, and it was slipping away.

So I started my interviews. I felt that it was imperative to preserve what I could of Steinbeck's local history. Of course, what I found was a simple and obvious truth that Steinbeck—one of our greatest fiction writers—wasn't writing fiction at all. His characters had lived, and their stories were real.

People also ask me why I chose the personal interview format for a book on Steinbeck. I guess it's because I often find unexpected

and fascinating information this way. In a personal interview, the interviewee is so relaxed that long-forgotten anecdotes often come to the surface.

Steinbeck's writings are simple and straightforward, but I think this is deceptive. His compassion and feeling for the common man are a continuous thread in his writing. My "day job" is that of a school counselor, and I'm sure that's one of the main reasons I'm so attracted to his work. One of the values of these interviews is that they illustrate this quality in Steinbeck, the man as well as the writer. The variety of views expressed in these interviews also illustrates the complexity, not the simplicity, of the man.

In order to obtain these interviews, I had to become a literary detective. They required that I travel to such dissimilar destinations as a remote ranch in the Santa Cruz Mountains, a well-run nursing home in Salinas, and a retirement colony in Lake Havasu. Like Steinbeck, his friends were all interesting. They were different from each other, but they had one trait in common: they were all strong, independent thinkers.

Once "Sparky" told me that he didn't recognize Steinbeck in the picture of him in later years, dressed in a tuxedo, which hangs in the Steinbeck Library in Salinas. "He just wasn't the same guy," said Sparky. A lot of critics and reviewers agree with Sparky and say that his best work occurred during the California years.

That's why I think these interviews are valuable. They show the young Steinbeck, as he was then, and some of the people and places that shaped his writing. They are full of new information and important insights, and help to explain why he is referred to as a great California writer.

Audry Lynch

The Salinas Years

1902-1919

Mary Ballantyne, Campbell, California

The director of the Saratoga Senior Center asked me to be one of their monthly luncheon speakers. According to my usual habit, I answered, "Sometimes I learn more about John Steinbeck from my audience than vice-versa. If anyone knew him or anything about him, I hope they'll see me after the lecture."

I was still at the podium rearranging my slides when a small, quiet woman said to me softly, "I never tell anyone this, but John was my next-door neighbor. I was one of the Williams sisters."

Before she could get away, I had extracted her telephone number and a promise to talk to me. I felt as surprised and excited as if I had found a gold nugget on my front lawn. A few weeks later I was seated in her charming, antique-filled apartment in Campbell.

The apartment was as sparkling and charming as its owner. I learned that the antiques were inherited from her mother. There were plants everywhere, a piano, and some lovely paintings. She explained that the paintings were done by her son, an artist.

Mary was a gracious hostess and gave us a great deal of time. Dressed in an attractive pantsuit, she showed us her home and served us tea. She was so vibrant that she looked much younger than her almost eighty years. When she found out that I was a school counselor,

she shared her recollections of schools from the vantage point of forty years as a speech therapist. She was a warm, sensitive interviewee with happy memories of the Steinbecks. Her only concern was that she might violate their privacy or bring undue attention on herself.

What was it like to be John Steinbeck's next-door neighbor while you were growing up?

"I was fifteen years younger than him, and I remember that I had a terrible crush on him," recalled Mary Ballantyne. "He was an absolute heartthrob. I was the middle one of the Williams sisters and usually felt left out, but John Steinbeck was always nice and paid attention to me. He was the opposite with my sisters and teased them unmercifully."

There were lots of similarities between the two neighbors, the Steinbecks and Williams. Both sets of parents were conservative Republicans, attended the Episcopal Church, and had three daughters and one son. Each family even owned an Airedale named Sandy. According to Mary, the last fact irritated John Steinbeck because "he said we stole his dog's name."

Mary remembered that John was fascinated by her brother, Jim, and always looked up to him. Unfortunately Jim died of alcoholism, but he does survive in Steinbeck's books. "I'm sure that my brother was the model for Jim Munroe in *The Pastures of Heaven*," said Mary. "That's why the locals hated John so much. They recognized themselves in his novels."

Despite the similarities between the two families, trouble did occur, as it often does between next-door neighbors. Mary's father decided to modernize their old Victorian home. This infuriated Mr. Steinbeck, who felt that this ruined the Victorian appearance of the whole neighborhood. "John's father was right," laughed Mary, "and personally we loved our old Victorian. The two fathers didn't speak for three years. John's sisters, Esther and Beth, were crazy about Dad, so they managed to heal the rift."

Mary was also allowed a rare glimpse into the author's writing habits: "Every weekend after John married Carol, Mrs. Steinbeck would bake some goodies to take over to them at their house in Pacific Grove. I would beg to go too, so I hid in the back seat. John would take walks with me, and he would tell me about his writing. He told me that writing was terribly hard work, a real agony. He was writing a book at the time, and Carol was typing it. I could see for myself that his whole floor was covered with balls of crumpled-up paper. He would write one sentence over and over until he got it right. Although it was agony, his talent drove him. He couldn't put it aside."

What were Mr. and Mrs. Steinbeck like? Mary remembered fondly: "They were the sweetest couple in the world, and they loved children. I would go over every day after school, and my mother would tell me to stop bothering them. Mr. Steinbeck made homemade root beer in the cellar for us. Of course, he was retired by then. Mrs. Steinbeck then would come out with a tray of homemade ginger cookies. They were very good to me."

As a close neighbor, Mary had a chance to know first-hand Steinbeck's parents' reaction to his dream of being a writer: "When he was up at Stanford they were very worried and discouraged about him. Mrs. Steinbeck always hoped he would be something respectable like a banker and 'get over the silliness of writing.' His father was much more sympathetic to his dream."

According to Mary, it was her own mother, Emily Williams, who first understood Steinbeck's genius: "John brought home copies of his first novel, *Cup of Gold*. After she read it, she told his parents, 'John is a genius. Support him!' Then the Steinbecks, who were very loving people and adored their children, decided to send him a monthly stipend to live on."

Mary also met two of John's wives and remembered them well. Of Carol she said, "The Steinbeck family didn't like Carol. They thought she was too impressed with John's fame and celebrity. She

really loved the Hollywood connection. John was affected, too, for a while but came to his senses. The Steinbecks thought she was too ambitious, and then, of course, she wasn't faithful to John. They knew about the romance with Joseph Campbell."

Of Gwen, Mary said, "John had his sons during the summers, and he often brought them over to his sister Beth in Pacific Grove. I met Gwen over there and liked her. She was pretty but very heavy. She seemed like a very down-to-earth person to me." Of Elaine, Mary recalled less. "I never met her, but Beth liked her very much. She told me that their relationship was beautiful and that 'she fit John like an old shoe.'"

Mary also knew the Steinbeck sons: "John tried hard with the boys, but he only had them during the summers. He was really obsessed with bringing them up the way he had been brought up by his parents. Unfortunately, they were in private schools all the time and very spoiled. I remember my kids going out with Tom and their dates to the Steinbeck movie theater in Monterey. He felt he should get in free because he was Steinbeck's son. They were spoiled by his money, and John felt frustrated because they didn't have the family values that he was brought up with."

Over the years Mary had occasion to become more involved with the Steinbeck sons. She used to see Tom at Beth's house "because he was a difficult kid and was having trouble in school." A few years before his untimely death, John IV started to correspond with Mary because he was writing a memoir about his relationship with his famous father. Before he could finish it, he died while having a back operation. His widow wanted to finish it, but Steinbeck's widow, Elaine, forbade its publication. "He begged me to write down for him everything I knew about the family," recalled Mary. "I remember his shock at finding out that his grandparents were Republicans. He was finally making his peace with his father when he died."

Like her neighbor John Steinbeck, Mary grew up with a strong

Elaine and John Steinbeck

feeling for the underdog. "I guess that sort of feeling is just born within a person," said Mary philosophically. "Steinbeck presented the Okies just as they were in the *Grapes of Wrath*. He was one hundred percent correct. When I was a Campfire Girl we visited the Okie camps, and I was terribly affected to see those proud, wonderful people hating to take charity."

Mary, who was looking forward to becoming an octogenarian, remained an advocate for the underdog. In high school she worked for migrant farmers and continued a lifelong support for Cesar Chavez and his work. After retiring from the Santa Clara School District as a speech therapist, she became an advocate for residents of nursing homes. She felt that farm workers and the elderly were two of the most badly treated groups in our society.

Privately she never mentioned her connection to the Steinbecks, and refused to capitalize on it. "It was just an accident of proximity," she said modestly.

The Bragdons, Salinas, California

At the Fourth International Steinbeck Congress, sponsored by San Jose State University, the weekend portion was held in Monterey, California. On Saturday morning there was a fascinating panel of local residents who had some connection to the Steinbeck legend. I was especially intrigued by a couple named Joe and Doris Bragdon of Salinas.

Their demeanor was modest, but they came prepared for their brief moment of fame on the stage of the educational building in the Monterey Bay Aquarium. It was a Saturday morning in April 1997, and the conference attendees were wearing down. In spite of that, a great number of them were in the audience with their eager questions.

The Bragdons sat next to each other and joined together in their answers. Their unity was not surprising in the light of their fifty-six-year marriage. Doris, a former schoolteacher, consulted a neat pile of white index cards she had brought with her. She and Joe seemed to enjoy the questions and answered them earnestly. After the session I climbed onto the stage, introduced myself, and asked if I could interview them. They were very gracious and open and acted as if they were delighted to share their information. They gave me their phone number, and I resolved to visit them soon.

A few Saturdays later I drove down to visit them in their charming

home on a quiet, tree-lined street in Salinas, Steinbeck's own home-town. They greeted me warmly and showed me their home, which held mementos of their worldwide travels, beautiful paintings (Joe had been a college art instructor), and family antiques, particularly from Doris's aunts, the Benjamin sisters, who were contemporaries of the elder Steinbecks. After the interview they served lunch, and then we toured their backyard and garden. It was a delightful and pleasant interview.

We started out by asking Doris what the locals had thought of Steinbeck as a boy, and this is what she told me:

"I used to constantly question Laura McGregor about him. She's dead now, but she graduated from high school with him. She told me that people around town really considered John to be quite odd. He would do things like wear a heavy overcoat in summer and travel around with derelicts. He would go out in the fields and talk to the farmworkers. That was something that middle-class kids in Salinas just didn't do then."

Her family had an even closer connection to Steinbeck through her aunts, Mary and Emily Benjamin, who opened their millinery store in the 1890s and were John's first employers. "They needed young boys to deliver their beautiful hats in boxes all over town. They paid five cents a box. Herb Hinrichs and John Steinbeck were best friends, and they became delivery boys. After a while they complained to their fathers that Miss Benjamin had stopped paying them. Unknown to them, Mr. Hinrichs had asked her not to pay them because they were eating too much candy. She saved up their wages instead and, after a time, gave them each a five-dollar gold piece. Herb Hinrichs still has his—the first money he ever made."

In later life, Doris met Beth, Steinbeck's older sister, in the Best Cellar, the gift shop at the Steinbeck House. "She remembered my aunts as wonderful, upright women. Of course Mrs. Steinbeck and her three daughters bought all their hats from my

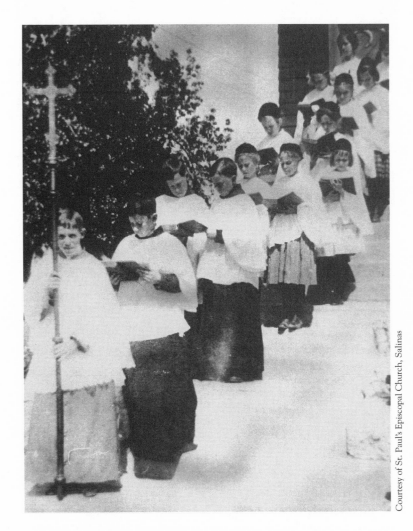

John Steinbeck (first on left) as a boy

Courtesy of St. Paul's Episcopal Church, Salinas

aunts. They lived a few houses down from the Steinbecks, and Beth said she remembered seeing them walking down the street every day to their millinery shop on Main Street."

Doris does admit that Steinbeck used recognizable local people in his stories. "There really was a Gross family who owned a cannery on Cannery Row, and I graduated with their children. Dr. Horace Harmody, mentioned in *Cannery Row*, was a real doctor who saved a lot of people in a flu epidemic. There really was a 'Sprague kid.' He lived across the street from my mom in Pacific Grove. Tom Work was a real person who owned a lumber yard. Señorita Maria was also a real person. Her family had a large Spanish land grant, which later became Laguna Seca."

Doris also remembered some of the two oddest characters in Steinbeck's novels, the flagpole-sitter and the seer: "I saw the flagpole-sitter outside of Holman's Department Store. There was another one on top of the San Carlos Hotel. My aunt drove us over to see him, and crowds of people came from all over the valley to see him. We all wondered how he went to the bathroom, and we later discovered that he used a can."

Her encounter with the seer, the same one that Doc encountered on the beach, was even more memorable.

"I saw him once when I was just a little girl, when I was looking out a second-story window in my aunts' house in Pacific Grove. He looked to be about seven feet tall, with flowing white beard and hair. He wore coveralls, and the pockets were stuffed with lettuce and fruits. He was the strangest man I ever saw, and I bet Steinbeck ran into him, too. In the book the seer lives on Asilomar Beach near a place we called the Rat's Nest. Now it's where the famous Spanish Bay Golf Course is located on the Seventeen Mile Drive."

She fondly remembered that "My aunt used to take us on outings in her old model-T Ford. She used to drive us up a hill in

Carmel Valley, the same place where Mack and the boys used to catch the frogs."

Doris also felt she knew the true story behind Steinbeck's famous strike novel, *In Dubious Battle*. "That strike took place right here in the lettuce fields of Salinas, not the apple orchards of Watsonville. The local sheriff didn't want the labor organizers, whom everybody referred to as 'commies,' in the fields. So he gave guns to the growers. People could hear gunfire in the fields, and people did get killed. My aunts, who had moved to Pacific Grove by this time, were afraid to drive over on Route 68 to do some shopping in Salinas. Those were dangerous times."

Growing up, Doris did not read the works of John Steinbeck. "Families wouldn't allow their children to read his books, and it was even more so in school. They told us he used bad language and wrote about no-account folks. Steinbeck ruffled the feathers of the middle class in Salinas, and they wouldn't forgive him. Salinas had a love/hate relationship with Steinbeck, and it lasts to this day."

Doris is the exception that proves the rule. "I've read most of his books, and I've even become a Steinbeck collector. We're members of the Steinbeck Society. He told it like it really was around here in the 20s and 30s. I admire him."

Joe Bragdon remembered landing on Cannery Row in 1937. "I was unemployed and looking for a job. There were thirteen canneries on the Row, and they employed about 2,500 people. On the day I interviewed, there were forty or fifty guys applying for the job, and only three of us were hired. I felt really lucky.

"Aside from canning, the main source of jobs was the reduction plant, using the wasted products of the fish for oil, fishmeal for cattle, or fertilizer. When I arrived, the union had already bargained our wage—fifty-seven and one-half cents per hour. There was no overtime."

Joe remembered the work as totally odiferous. "We were saturated with the smell. It was in every pore. On the way home from work, since we didn't have telephones, I'd stop at Doris's house to make a date. Her mother made me stand on the porch, downwind, and wouldn't let me in. Then I'd go home, undress in the garage, and jump into a bathtub."

In some ways it was exciting work. "A school of fish would appear. They would light up the sea with their phosphorescence. Then the purse seiners would scoop them up in their giant nets. The cutters were called first. Each cannery had its own distinctive whistle and code. You learned to hear your own cannery whistle in your sleep."

Joe rented a room next to Doc Rickett's Lab. "Doc was a very friendly, unassuming guy. I didn't realize at the time that he was a professional person. His place was full of jars and bottles and lab equipment. There were big cement tanks in back for his speci-mens. He was always willing to answer questions and was pretty much the way Steinbeck described him."

He remembered once walking along the Row with a bunch of guys and seeing the prostitutes leaning out of their windows. Sud-denly, a hefty woman yelled to them, "How would one of you guys like 300 pounds of a red-hot mama?" Joe laughed, "I guess that must have been Steinbeck's Wide Ida."

Joe admitted that he didn't know most of the characters Steinbeck wrote about because "I mostly hung out with my fellow workers." Doris remembered the characters, but Joe remembered the places. "There really was a dive called the Halfway House. It was a bar but, if you bought a drink, you could get a sandwich. You could bum a lunch for a dime. Holman's was the only department store in the valley. Red Williams did own a Flying A gas station, and I bought my gas there. There was a Herman's Restaurant on Alvarado Street, and a Scotch Bakery where you could buy a loaf of fresh bread for seven cents. The bakery is still there."

Joe arrived in the area because his parents were hired to run the dining room in the famous Mission Inn. He remembered a big change in prices. "My parents served a full-course dinner for eighty-five cents. Abalone cost sixty cents a pound. Now it costs seventy-five dollars a pound."

Although Steinbeck didn't write *Cannery Row* until the 40s, Joe felt he captured it. "It was a smelly, dirty street, not famous like it is today. Although he wrote it later, he depicted my time there with great accuracy."

Sophie Freire, Salinas, California

The Steinbeck Foundation in Salinas planned an exciting day of activities for the launching of the first-day issue stamp of James Dean. The members felt it was appropriate because of James Dean's famous role in Steinbeck's East of Eden. *While I was there I happened to pick up a copy of the local paper, the* Salinas Californian. *On the front page of the paper I saw a story about an old woman who had known Steinbeck in high school. Of course I had to meet her!*

I located her in a nicely kept nursing home on a side street in Salinas. She was sharing a room with another resident, and she was sitting up in bed watching TV when I found her. The first thing I noticed was that she looked much younger than her ninety years. Her skin was unlined, and her eyes sparkled. She asked me to identify myself, and she asked me so many questions that I knew her mind was unaffected by age. A copy of the paper with the feature about her lay on her bed. She was quick to assure me that she was still able to get up every day to attend Mass.

The presence of Steinbeck in Sophie Freire's life had been brief but memorable. She had seen him, like so many of his peers from that time have reported, as someone a little different from the rest

of his classmates—someone who, even at that early age, was somehow set apart. Perhaps because of this, he was also sensitive to someone else who might be considered different, like Sophie. The compassion he felt for an underdog—which would be brilliantly expressed in *The Grapes of Wrath*—was already at work.

Sophie was a shy freshman in Salinas High School who took the train every day from the factory town of Spreckels to school. John Steinbeck was a tall, good-looking senior who always took the time to acknowledge her whenever they saw each other around school.

"I guess he knew that I was scared and new to school in Salinas," recalled Sophie. "Whenever he saw me he'd give me a little wave, so I was grateful and always remembered him for that. I guess he felt sorry for me." Sophie also remembered Steinbeck as something of a loner. "He was very respectable, but he didn't mingle much with his classmates. I think it was because he was a very private person and came from that kind of family. We used to call him 'the quiet boy.'"

If Steinbeck was aloof from his classmates, he was very close to his sister, Mary, who was a sophomore. "I'd see them together a lot. She had beautiful blond hair, which she often wore in braids. One day she came in with her hair cut. She was the first girl in Salinas High School with bobbed hair."

She also remembered Steinbeck as a good student. "We weren't surprised at his fame, because we all expected him to be a writer. I have to admit, though, that we never expected him to win a Nobel Prize."

In later life Sophie had another connection to Steinbeck. Her husband, Barney Freire, drove a truck for Spreckels and used to drive to Stockton and San Jose to pick up sugar factory workers. Sometimes on weekends he would see John Steinbeck hitching a ride home from Stanford University.

Barney would give him a lift but, according to Sophie, they

never became close. "My husband wasn't particularly fond of John. Barney was very outgoing, and John wasn't much of a conversationalist. Besides, when they stopped John never paid for his own coffee."

During her long lifetime (Mrs. Freire recently celebrated her ninety-first birthday), she has read three Steinbeck books: *Of Mice and Men*, *The Grapes of Wrath*, and *East of Eden*. To get to Salinas High School she rode the "Spreckels Dinky," a steam engine and single railroad car that served as a school bus. It chugged along the countryside, so Sophie said of the Steinbeck novels, "I recognized his descriptions of the area and how people lived. It was all very familiar."

Sophie also remembered that not everyone liked Steinbeck as a young man. "Some people really liked him a lot, but there were others who talked against him. They called him a bookworm and felt that he thought he was a little above them."

Sophie's father, Anthony Cemara, worked as a mechanic for the Spreckels Sugar Company. Sophie was born in Hawaii, but the family moved to California in 1906. They were staying with relatives in Oakland when the great earthquake came, and they watched the fires in San Francisco. She grew up and lived in Spreckels for forty-four years. She married in 1925 and "bought the first lot in Mission Park, 808 Padre Drive." She and her husband had one daughter, two granddaughters, and one grandson.

She was very proud to have been a schoolmate of the famous Steinbeck. "His writings help draw people to this area to find out that Salinas is a nice city."

Sophie's favorite Steinbeck book is *East of Eden*, but she does have one regret: "I recognized a lot of local people when the movie came out. I just wish they had asked me to take part in it."

Herb Hinrichs, Salinas, California

Every summer during the first weekend in August, there is a wonderful Steinbeck Festival in Salinas. Since I have summers off, I try to attend the festival as often as possible. One of my favorite events is always a panel called "Friends of Steinbeck." I love the intimacy and authenticity of this presentation.

It was after one such panel that I met Sparky Enea, the subject of my first book, *With Steinbeck in the Sea of Cortez*. In addition to Sparky, I was also fascinated by a speaker who was present every year—Herb Hinrichs, a sprightly octogenarian who had a self-effacing manner and a great sense of humor.

When I thought of this project, I simply called him up and asked him if he could talk to me about John Steinbeck. He was totally open to the idea and agreed very enthusiastically to meet me. I made reservations for lunch at the Steinbeck House on Central Avenue, since Hinrichs still lived in Salinas with his wife of fifty-six years, Florence.

Herb and Florence, dressed in their Sunday best, were waiting for me when I arrived at the Steinbeck House. Many of the other diners, including the ladies who volunteered there, were greeting Hinrichs and his wife, eagerly engaging them in conversation.

They enjoyed a glass of wine with dinner and ate heartily. We laughed and talked, and they described their life together (they still go dancing regularly), their sons, and grandchildren. Plans were under way for a party to celebrate Hinrichs's ninetieth birthday.

It wasn't until lunch was over that we discussed his friendship with Steinbeck. Hinrichs chose to sit under a portrait of Steinbeck in the living room, where Steinbeck had been born. While we talked visitors kept peeking in at us, and Hinrichs obviously enjoyed being the oldest living friend of Steinbeck.

Despite their close friendship, their life paths had diverged dramatically. Hinrichs was the hometown boy who had been content to stay in Salinas, marry, and raise his family there. Steinbeck's life in Salinas, on the other hand, filled him with the desire to get out as soon as possible and travel the world. Hinrichs was well liked in Salinas, proud of the fact that all his jobs had been obtained through friends. Steinbeck was the local radical who turned his back on his hometown, whose memory still produces enmity in some quarters. Hinrichs and Steinbeck each represented "the road not taken" to each other.

Herb Hinrich was John Steinbeck's oldest friend, the only one of two childhood friends whom Steinbeck's strict mother would allow into the Steinbeck house. They lived on the same street, started in first grade together, and went to the same Sunday school at St. James Episcopal Church. You might say the friendship started even earlier, because both their fathers worked together for the Sperry Flour Company, first in King City and then in Salinas.

What did Hinrichs remember most about the old friend he never dreamed would become famous? "John was kind of a lazy fellow," laughed Hinrichs. "He got fired from every job he had around here. He didn't really like to work until, of course, he got around to writing."

Hinrichs remembered Steinbeck's mishaps on the job vividly. "Once he had a job building Highway 1 around Big Sur. I met the

superintendent from it and he said they'd kill John if he ever came back."

Later Steinbeck was fired from his job as a night chemist at the Spreckels Sugar Company. "They said he was useless. Later he worked on the company's Ranch Number 9 in Soledad. There he met the models for the two groups of men he immortalized in *Of Mice and Men*."

Steinbeck also had a job as caretaker of an estate in Emerald Bay and worked part-time in a fish hatchery in Lake Tahoe, where he met his first wife, Carol. Hinrichs laughed about Steinbeck's career there. "John would tell visitors he was Dr. Steinbeck, a pis-catorial obstetrician. A forest ranger told me that he used to break into these conversations by saying, 'Tell them, John, about the time you had to use the forceps.'"

Unlike Steinbeck, Hinrichs learned the value of hard work early, when he had to quit Salinas High School after two years because his father had died. Hinrichs stayed in Salinas to become a mechanic, a hardware salesman, a gas station owner, a soldier, a farm equipment mechanic, and, eventually, an appraiser in the county tax assessor's office. He was surprised at Steinbeck's work history and concluded, "John just couldn't hold down a job very long."

As a playmate, Hinrichs sometimes found Steinbeck "an odd boy. He didn't play marbles, or skate with us, or ride a bike, just street games like kick-the-can. His mother was so strict that I think it caused him some problems."

One of the games that Mrs. Steinbeck objected to was a game of war with toy soldiers. "John loved that game," recalled Hinrichs, "so he used to come over to my house to play it." Together with Glen Graves, another friend and neighbor, they would match the soldiers with their names and start firing with a toy cannon. Hinrichs still has two of those toy soldiers, which he has willed to his daughter as a family heirloom.

Like most of their friends, the two boys attended Sunday
school faithfully. Hinrichs remembered one humorous incident
which illustrates that, as he said, "John had his own way." This is
the story: "Bishop Nichols came down for confirmation, and John
was carrying the cross at the head of the procession while I was
singing in the choir. There was a little latch to keep the cross in,
and John forgot to use it. The cross fell and hit the Bishop on the
head. The whole congregation was mortified, but John was not
fazed a bit. He just picked up the cross and put it back."

Because the two families were close neighbors on Central
Avenue, Hinrichs was privy to the Steinbeck family dynamics.
"Ernst, John's father, was very quiet, but Olive, his mother, had a
vinegar vein. She was always trying to get into high society. Mrs.
Graves, Mrs. Steinbeck, Mrs. Warner, and Mrs. Conner were the
four women who ran the town."

Hinrichs felt that Steinbeck was definitely closer to his
mother than to his father. "One thing I'll have to say is that John
was very good to his mom. In her last illness he came home to take
care of her, even did her laundry. He was here for months, but
nobody saw him."

What was Steinbeck like as a classmate? "He was an odd boy,"
said Hinrichs. "He was a loner who would sometimes walk by you
with his head down. The next day he would surprise you by saying
hi. I guess he was thinking about things."

That type of preoccupation didn't preclude Steinbeck having
a sense of humor: "His type of humor was very dry. I never heard a
belly laugh from him. He loved to play pranks on everyone. Dur-
ing World War II we'd save balls of tinfoil. He sat two or three
seats away from me and passed me a ball of it as a gift. I was ex-
cited until I found a large chunk of Limburger cheese inside. Then
I got mad at him."

In high school, Hinrichs recalled, there was one incident in
which Steinbeck was mad at the local police. "He went to the Old

Victory Grill and stole a beef roast and threw it in the City Hall door." That was back in 1915 and, yes, Steinbeck got caught and was taken into police custody.

Of course, Steinbeck's writing ability also showed up early. Hinrichs remembered that he had an excellent memory and a wonderful knack for words, both slang and high tone. Once his writing ability backfired on him in school: "We had a classmate called 'Pickles' who couldn't write a thing. John told him that he'd write his composition, and Pickles just had to copy it. The teacher called it the best one in class. Steinbeck protested and the teacher answered, 'If that had been yours, it would have been good; but for Pickles that was excellent.'"

Hinrichs also had some "inside" information on the Steinbeck books:

Cannery Row: "I'm the character of little Andy in the book, the one who played the prank on the Chinaman. There was a Chinaman who came to our two homes to pick up the laundry. John dared me to sing the verse:

Ching Chong Chinaman
Sitting on a rail
Along came a white man
And chopped off his tail.

I did so, and the other kids ran through a hole in the fence and the furious Chinaman turned me over his knee and spanked me."

The Grapes of Wrath: "John told the absolute truth about the migrant workers. The old timers used to say, 'Don't talk to Steinbeck.' He rattled too many skeletons in the closet. Once, on a visit, he dropped into my service station and didn't visit anyone else. I asked him why he didn't move back, and he said, 'If I came back to Salinas, they'd kill me.'"

Of Mice and Men: "He was working on the Spreckels Sugar

Company's Ranch Number 9 in Soledad when he met the characters for that book."

Winter of Our Discontent: "He mentions learning how to walk up and avoid the squeaky stairs. That's what he did in his own home."

In Dubious Battle: "That was based on a strike we had in Watsonville. John was accused of being a commie, but he never was and never would be."

The Red Pony: "He made part of it up, and part of it he didn't. He had a pony with a square cart. He used to keep it on an empty lot next to the house, but it stayed out in the weather 365 days a year. So finally it got sick and died."

East of Eden: "All the big shots in town recognized themselves, and they didn't like it. I could name all those people, but I never will."

Hinrichs always enjoyed participating in the "Friends of John Steinbeck" panel, and was as sorry as anyone to see it discontinued recently. As he said ruefully, "There aren't many of us left."

Cannery Row

1930-1936

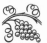 Nan Fowler, Vineburg, California

Through a mutual novelist friend, I met Jim Lyle, a poet who knew most of the beat poets. He used to come to speak to my English classes at Mission College, so he knew of my interest in Steinbeck. He recalled that he knew someone who had known Steinbeck, Nan Fowler. Here is what he remembered:

"Nan and I used to know each other when we lived in Sausalito. She was a lot of fun. Every time we met, she'd start a song and I would finish it. We had a lot of laughs with that. I know she lives up in the wine country, and I have her phone number. Give her a call. She has a letter from Steinbeck."

Of course I was intrigued by the letter, so I called her a few times. She was warm and receptive on the phone but declined to sell the letter. Generously, she did send me a xeroxed copy of it. She invited me for a visit, but it was several months before I accepted because she lived about a three-hour trip from my house.

My husband attended a cribbage tournament in Napa so, on the way home, we veered off on a back road and drove to Vineburg. It was an eye blink of a town, and we found Nan's house very easily. It was an old one-story affair set back on a country road, and it displayed a casual housekeeping style, lots of old books, and an artist's studio.

Nan came down the steps to meet us, followed by her cats. She wore Levis and still looked very attractive. At the time she must have been in her seventies, but she had a youthful appearance and personality. It was easy to establish a rapport with her because of her openness and childlike spontaneity. Before long she had confided in us the story of the men in her life, memories of her mother and father, and the poignant story of her reunion with a son who had been given up for adoption.

It was easy to see that her unconventional life had developed from her concentration on her art. Her paintings were light and bright and as full of joie de vivre as she was. Naturally we bought a print of one of her favorites, which still hangs in the kitchen.

Nan was also a natural storyteller. We drifted out to the patio, where over cold drinks she regaled us with stories of her father, Toby Street, and John Steinbeck. With great pride and animation she read Steinbeck's treasured letter to her. The visit ended with her showing us the secret place where she hid the letter for safekeeping.

From Nan we saw Steinbeck through a child's eyes. She remembered John Steinbeck as a resident Dutch Uncle.

"He was a frequent guest at our house," recalled Nan. "When he was between wives he always stayed with us. I think my mother, Frances Price, considered him a pest; but we children were in awe of him. I remember his craggy face and beautiful blue eyes. Later on in life I think he reminded me of Anthony Quinn."

Nan remembered Steinbeck as a man who "loved kids but also liked to tease them." She vividly recalled an incident in which this became a problem for her. "I was sitting on my bed reading my favorite book at the time, *The Raggedys in Fairyland*. He asked me what I was reading, and when I showed him he said, 'Why aren't you reading something realistic?' As the child of literary parents, I was embarrassed by his question. It made me angry, so I threw the scissors which I used to cut my paper dolls at him."

This must have made Steinbeck feel bad for hurting her

feelings. "No one had ever questioned my reading habits before. A few weeks later he wrote a letter of apology for hurting me. He enclosed a book called *The Burro of Angelitos* by Peggy Pond Church, a friend of his. I treasured that book for years."

Nan also recalled how her father, Webster "Toby" Street, and Steinbeck met. "Dad had just come back from World War I and he wanted to be a playwright. He went to Stanford and enrolled in a class with Professor Marge Bailey, and Steinbeck was also in the same class. She was the 'guru' that they had in common."

Then Nan shed more light on the literary relationship between the two men by reading the letter from Steinbeck that she still treasures. In it, Steinbeck blames her mother and grandmother for stopping Toby's career as a playwright: "It wasn't so. Toby loved the law. He gave his favorite play, *The Green Lady*, to Steinbeck, but Steinbeck added his own characters."

A few years ago, a mutual friend brought Ed Ricketts, Jr., over to Nan's house for a visit. "I read him the letter and he said, 'This is just like hearing him again. Your father wrote a lot of John's stuff.'"

Nan denied that this was true: "Sometimes Toby would offer John a suggestion, but it was for friendship, not to get credit. After all, a man who won the Nobel and Pulitzer prizes didn't need much help. They would compare notes, and Toby offered John emotional support with great joy. The had a lot of fun together. When Dad died, my sister Claudia said, 'I bet those two are up in heaven talking up a storm.'"

Toby also tried to help Steinbeck out financially. After Stanford, when Steinbeck needed a place to write, Toby got him a job as caretaker at the Fallen Leaf Lodge at Emerald Bay, Lake Tahoe. Nan said, "At least it gave John a place to write his first novel, *Cup of Gold*. My grandpa had started it as a boys' summer camp, but afterwards my grandparents transformed it into a beautiful resort. John didn't work out well as a caretaker because basically he was a goof-off. But my mother and grandmother were also

very fussy and hard to work for. So John moved on to a job in the fish hatchery, where he met his first wife, Carol."

What did she remember of Carol? "I loved Carol," said Nan. "She was a very funny lady. I can see her now, always smoking, always with a drink in her hand. I don't know what happened—Toby handled their divorce—but at one time John and Carol were right for each other. When she died, Dad was stricken. They had known each other for years, always traveled in the same circles."

Nan's most vivid recollections centered on Steinbeck's musical, *Pipe Dream*, Rodgers' and Hammerstein's only failure. In her younger days, Nan lived in Sausalito in an apartment remodeled from the old post office. As an aspiring singer, she used to frequent the No Name Saloon, a hangout for writers, artists, and actors. The local production of *Pipe Dream* was scheduled for a six-week run, but it proved so popular that it was held over. The lady playing the part of Fauna had other plans, so Les Abbot, the director, asked Nan to think about filling in. Before he was out the door, she had accepted.

This is how Nan recalled the experience: "It was 1957, and I had let them use my home for rehearsals. I was in the chorus and had done the scrim for them. Doug Miller, the music director, came over every day to help me. I learned the part in one week, and I still remember all the songs. My favorite song is 'The Happiest House on the Block.' The gal who played Suzie lived in town, and she helped too. I asked Steinbeck to send the director a telegram about the play, and when Les Abbot received it he was amazed and delighted."

When Steinbeck came to California while driving around for material for *Travels with Charley*, Toby told his daughter that Steinbeck would be having dinner with them in Pacific Grove. Steinbeck, in discussing the play, asked, "How did it go?" When she answered, "It ran for eleven weeks," he responded, "That's longer than it lasted on Broadway."

She remembered that Steinbeck had been very disappointed in the Broadway production and that Richard Rodgers had written the whole thing in one afternoon. Steinbeck had said, "Rodgers didn't understand that Suzie was not a professional nurse, but a real whore. I guess they [Rodgers and Hammerstein] concentrated on the humor because they didn't understand it. They had never been to a whorehouse. It should have started in an off-Broadway production."

Contrary to what one might expect, the two old friends usually did not discuss literature. "I would be cooking dinner," said Nan, "and they would be in the living room fighting the Punic Wars. They were always arguing about history, not literature."

After one of his divorces (Toby was married six times), he rented a cottage on Delores Street in Carmel, where Nan kept house for him. Since he was a "neat freak," she spent a lot of time straightening out his belongings. She remembered finding a notebook full of entries and dates. She remembered one of his entries that said, "Got a letter today from J.S. on some homemade stationery. Poor John. He'll never be rich!"

Toby kept all his letters from his friend and donated them to Stanford University. Nan remembered that Toby liked *The Red Pony* and *Burning Bright* the best of all his friend's works. She has a signed copy of *The Grapes of Wrath* and said, "I still enjoy every word of it. About every ten years or so I reread *East of Eden*, whether I need it or not."

Nan was happy that *Pipe Dream* is still offered regularly by small theater companies because of its low royalties and easy sets. She said that her father always felt that Steinbeck always missed the Bohemian life that the play represented. She also liked the play because of one special line that mentions the "Webster Street Lay-Away Special," the name of a martini with chartreuse. "Steinbeck made the perfect memorial for Dad when he named a drink after him," laughs Nan.

Jimmy and Frank Rodrigues, Monterey, California

On the same panel where I met the Bragdons were two brothers named Rodrigues. They had known Cannery Row intimately in the 30s and 40s, when Steinbeck and Doc and their friends lived and worked there. They gave us rare glimpses into those lives from the vantage points of their jobs during that time—Jimmy's as the cop on the beat, and Frank's as a grocery clerk in Espinola's market.

Their parents, who had married in San Francisco, moved to Cannery Row in 1916. The family's first home was on Cannery Row right across from Wing Chong's market. The brothers grew up in Monterey, attended school there, and married and raised their families there. They still live in Monterey in small, well-kept homes in the same general area in which Jake Stock lived.

Because of their extended families and long work histories, the Rodrigueses seemed to know everyone in Monterey. They also exhibited great senses of humor. On the stage panel Frank admitted, "Of course all those whorehouses existed. I ought to know, because I patronized every one of them." After the panel, when I asked Jimmy if I could interview them, he grinned and said, "It will be all right after I clear it with my wife." Both of them are well into their eighties.

Jimmy gave me extensive directions on the phone about how to find

his home. He must have been worried about my arrival, because he was waiting by the front gate for me. He led me through a well-kept yard into an immaculate and nicely appointed living room. He introduced us to Mrs. Rodrigues, his wife of over fifty years, who quickly excused herself. We settled ourselves around the large oak dining room table while Jimmy explained that Frank couldn't come because of recent health problems.

Just then there was a loud knock on the door; it was Frank. Despite his health problems, he didn't want to be left out of the interview. Also, in spite of the fact that he was the older brother, he deferred to Jimmy to start the interview.

"What was it like to be a policeman along Cannery Row in those days?" I wondered aloud. Jimmy explained it as follows:

"I had the night shift on the Cannery Row beat from 1937 to 1942. I had to keep law and order without any radio systems or back-ups. Of course, there weren't so many crimes. Mainly there was a lot of family fights. Everything has changed now, of course. It was rough work, but I made the best of it."

Did he see John Steinbeck on Cannery Row in those days, we asked?

"Sure I did," Jimmy replied. "He used to drive down to visit Doc Ricketts at the lab. He was never dressed up. He'd come down in a cotton shirt and faded jeans carrying a jug of wine. I don't think he owned a suit of clothes at that time."

"What did you think of Doc Ricketts?" was my next obvious question. At that, Jimmy really warmed up. "He was a very nice and very quiet person. I remember that he used to buy a lot of cats from the kids."

A big part of Jimmy's job was to police the places that served liquor and make sure they did not serve liquor after closing hours. He also had to go in to break up the fights.

His night beat brought him into contact with the local

madams. At that time, the houses of prostitution operated freely because they were condoned by the local police chief. Jimmy said, "The girls were clad in negligees with no underwear to entice the men. All the girls were registered so that they could vote in the local school board elections."

Jimmy said that the three main madams were highly competitive and also different from each other. "Flora was a big, fat woman who sat at the end of the bar and recorded all the transactions each time a girl took a man into a room. She controlled all the activities at the Lone Star. Really, she was a wonderful woman, not hard at all.

"Ida, on the other hand, was a very hard woman. Her man was called Jim, and he acted as her bartender and bouncer.

"Grace was the owner of the Marina Apartments. I wasn't too well acquainted with her."

Jimmy also remembered that the so-called "characters" in Cannery Row were actual people that he had known and dealt with every day. "I knew Whitey, Blackie, Gabe, and all those guys. They were bums along the Row who used to sleep in the old boilers."

From this group, Jimmy picked out the model for Steinbeck's "Mack": "It had to be Gabe Bicknell. He moved here from Santa Cruz. He was a good mechanic, except when he got drunk with his buddies. He loved to dig frogs, and he'd carry a bag of them into a bar. Then he would drop salt on them so they would hop all over the bar."

Was *Cannery Row* accurate? "It was pretty accurate," Jimmy said thoughtfully, "until the sardines got all fished out. Some people think Steinbeck is important because he wrote books and made a lot of money. Personally, I didn't think he was anything to get excited about."

Frank Rodrigues, the oldest child in the Rodrigues family, did not graduate from Monterey High School like Jimmy. His father's fish

processing business failed, which necessitated his going to work right after the eighth grade. For thirty years he was the Monterey Superintendent of Mail. Before he passed the post office exam he worked in a cannery and then as a clerk in the produce department of a grocery store on Lighthouse Avenue. In that capacity he met Steinbeck and many of the characters he immortalized in *Cannery Row*.

This is how he remembered Steinbeck: "He used to come in with his wife, Carol. The first thing he did was buy a quart of whiskey and some Bull Durham tobacco. Then he would go out and sit in the car while she did the food shopping."

Frank remembered Flora's shopping jaunts even more vividly. "Flora used to arrive two or three times a year in an old touring sedan with the Old Swede. She would hang two wicker baskets over her arms, two over the old Swede's, and two over mine. That made six baskets in all. She would deliver it all to the poor in Seaside and Monterey. At Thanksgiving she went all out. She was a very giving woman and wouldn't stand for any dishonesty. The fishing industry died, and then during World War II the officers at the presidio closed her down."

Frank also remembered Wing Chong's. "I went to school with his son. We used to buy his coconuts, lichee nuts, and sugared pineapple slices. When we were kids, that was our candy."

As for Steinbeck, Frank remembered him as part of a particular group of friends. "He liked his liquor and had a group of friends. He hung out with a guy named Ray Rudolph and Dr. Tawse, a chiropractor. Personally, at the time I was not impressed with him."

Virginia Scardigli, Palo Alto, California

For many years I saw Virginia Scardigli at Steinbeck conferences and meetings, but she avoided me. Later I learned through a mutual friend that she had heard a story that I had told involving Carol Steinbeck's drunkenness. As a longtime and loyal friend of Carol's, she was naturally offended and angry with me.

Still, we kept on meeting each other because of our strong common interest in Steinbeck's writings. For my part, I always admired Virginia. She was—and is—a striking figure in any gathering. She's tall, stately, and very elegant-looking with her white hair swept up high on her head. When she offers an opinion, she delivers it in such an articulate and commanding way that her nineteen years as an English teacher echo in every word. In any group of Steinbeck scholars and enthusiasts, she can speak with such authority because she is often the only person in the room who actually knew him!

Then all the years of coolness melted when a mutual friend invited us to speak at the California Regional English Teachers Conference in San Jose. We were both invited to speak on Steinbeck, with my presentation immediately following hers. It seemed as if half the attendees at the conference, including me, attended Virginia's session. No one, except me, attended mine.

Perhaps out of sympathy, or because we admired the same English teacher, or just out of years of running into each other, we enjoyed lunch together at the conference. We started talking about all sorts of things. We are both avid travelers, and I listened in awe to Virginia's tales of driving around the country by herself. Finally I invited her to do an interview, so she followed me home in her car.

We started the interview in my kitchen, but we moved out onto the deck for better lighting for the camcorder. Later Virginia told me that her only son, with whom she is very close, enjoyed the videotape but was critical of the lighting. Virginia made a wonderful interview subject because she was so relaxed, so articulate, and seemed to enjoy having her picture taken. She sat back with her wine and her cigarette and just let it roll. Like many other people from Steinbeck's circle, she was so lively that she seemed much younger than her age.

She talked freely about her marriage to and divorce from the sculptor Remo Scardigli. She never married again but pursued a career of her own while raising her only son. One senses a great spirit of independence in her.

I invited her to stay for dinner, but she declined, saying that she wanted to be back at her apartment before dark. She lives in a 1952 Eichler house in nearby Palo Alto. Not driving after dark seemed to be Virginia's only concession to advancing age. Virginia currently acts as a "keeper of the flame" in Steinbeck memoirs. She is quick to point out any errors or misinterpretations of the Steinbeck life in the light of what she personally observed. But I think her main insight into the Steinbeck story is the role that women played, or didn't play, in his life and literature. As the confidante of two of his three wives, she is in an excellent position to give the woman's perspective.

"Steinbeck and I became friends because we were so alike in many ways," said Virginia Scardigli. "We both had been early readers as children; we were shy; we were fond of going off alone; and we both were products of Episcopalian Sunday schools."

How did they meet? Virginia, a U.C. Berkeley graduate, lost her job at Roos Brothers in Oakland and moved to Carmel in 1935. "Jobs were scarce during those Depression years," recalled Virginia, "so we all had to take a lot of part-time jobs." In Carmel she ran a boarding house, sold advertising for one local paper, *The Carmel Cymbal*, later bought by the *Pine Cone*, and, most interestingly, she worked as an artist's model for one dollar and fifty cents at Clay Otto's class.

"It doesn't sound like much," laughed Virginia, "but in those days it was enough to buy my food." One of the artists she posed for in the class was Fred Strong, Ed "Doc" Ricketts's brother-in-law. Through him she received an invitation to join the "lab crowd," which, of course included John Steinbeck.

She found Steinbeck and Doc quite different from each other, but she was fascinated by their unique friendship. "Doc was a warm guy whom everyone loved. He was a fantastic listener who loved philosophical ideas. He was a first-rate scientist with an imagination backed by an Einstein type of mind. His book, *Between Pacific Tides*, was a real breakthrough. John was compassionate like Ed, but he was volatile too. Ed was only four years older but seemed maturer."

Virginia often joined Ricketts in his collecting in the local tide pools. In the introduction to the *Annotated Phyletic Catalogue of the Sea of Cortez*, she is recognized as "an efficient associate and a pleasant companion during some of the bibliographic research." Since she worked on the phylum catalogue, she was a first-hand witness to some of the publishing struggles that occurred over Steinbeck's *Log from the Sea of Cortez*.

"Steinbeck kept fighting to have both names, Steinbeck and Ricketts, on that book," she explained. "On the trip Steinbeck hadn't kept his own log, so he relied on Ed's and Captain Berry's. That part about nonteleological thinking is straight Ed, not John.

But don't get me wrong, there was no jealousy or animosity be-
tween the two over that. Ed was not at ease as a writer, so he was
satisfied that John's name was on the book."

Virginia first met John and Carol Steinbeck at the lab after
their return from Mexico. "John had made $3,000 from the sale of
Tortilla Flat. He paid off all his bills and his friends' bills, and he
had enough left over for a three-month trip to Mexico. He really
enjoyed telling us the stories of how Carol's bastardized Spanish
had gotten them into some scrapes."

And what of Carol? Virginia said, "Carol had a foul mouth but
a great sense of humor. I guess she had great urges to get away from
a small town, which San Jose was at the time. I remember going
on shopping trips with her and her sister, Idell Budd, up to San
Francisco for Idell's mother-in-law, who owned a dress shop in Ho-
nolulu. Carol was a beautiful gal, but her pictures never did her
justice. It was her personal animation that made her beautiful. We
had a lot in common because we were both supporting artistic hus-
bands."

Virginia was also privy to a near-catastrophe to another
Steinbeck novel. "We went over to visit them and there was
deathly quiet about the place. John was sitting in front of a gallon
of red wine, and Carol was curled up in a windowseat. Everyone
looked sad, including their pup, Toby. I asked what had happened
and John said, pointing to the dog, 'He ate the whole book.' The
dog had gotten into John's writing shed, an old chicken coop, and
eaten about three quarters of the manuscript, and John had no
notes. Later John called Toby a good critic. I asked how long it
would take to rewrite the book, and he told me, 'About two
months.' He wasn't mad at Toby. John always forgave dogs."

Among the bohemian set on the Monterey Peninsula at that
time, leftist politics were in vogue. Virginia said that most people
felt that the communists were the only ones showing concern for

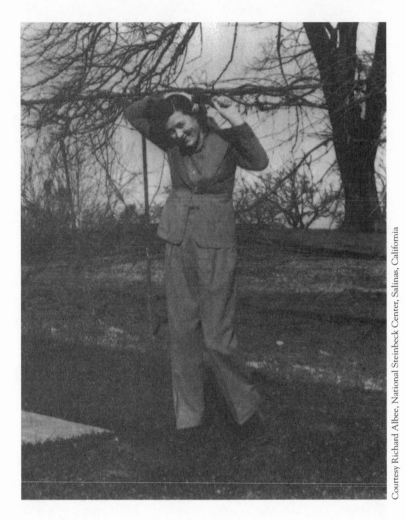

Courtesy Richard Albee, National Steinbeck Center, Salinas, California

Carol Steinbeck

the underdog. At one point she recalled that she and her husband were followed by both the communists and the members of the American Legion, because no one was sure of where they stood.

Were the Steinbecks communists? "Carol did join the Communist Party, but later she realized it was a mistake," said Virginia. "John never did. He liked to study the philosophy of politics, but he didn't like power plays. In his famous strike novel, *In Dubious Battle*, he shows the shortcomings of both the commies and the growers."

That led to a funny misinterpretation that Virginia stressed. "The wife of Lincoln Steffens only read half the book and wrote a glowing review because she thought it was pro-communist. When she went home and finished the book, she realized that John was hard on the communists too. I was working in the paper's office at the time, and I remember her dashing in shouting, 'Stop the reviews!'"

According to Virginia, Steinbeck was as individualistic in his religion as in his politics. She was able to give me some new insights into *East of Eden* when she said, "My religion is vertical. It goes straight to God without any intermediaries, and I suspect that Steinbeck was the same. He knew his Bible and loved the King James version."

She also felt that the book gives us some insight into his family relations. "I was shocked in the Garden of Memories Cemetery when I read the dates and realized that Sam Hamilton had died when John was only two. So the portrait of his grandfather was not his real grandfather, but rather the one he wanted and needed. He used a lot of the characteristics of his second wife, Gwen, when he devised the character of Kate."

While sipping a glass of wine, Virginia admitted that "we all liked to drink in the thirties. It was a form of rebellion against Prohibition. John was a heavy drinker, but he never drank while he

was writing. He would always stop then. Gwen was an alcoholic and he felt very badly about his sons' drinking."

There was a lot of pain in the relationship between Steinbeck and his sons. "Unfortunately," said Virginia, "Gwen always told the boys that John was bad. He only had them during the summers. They were just starting to get close when he died."

Virginia attributed Steinbeck's literary success to the following: "He was a guy who decided to be a writer, and he stuck to it. He also had a good agent and a good publisher. Writing for him was like sex. It was fun."

For nineteen years Virginia taught English and reading at Balboa High School in San Francisco, at Fairfield High School, and at Gunn High School in Palo Alto. She learned first-hand Steinbeck's appeal to students. "They liked his simple language, and I tried to show them his meaning and his humor. Most of them would have liked to have Lennie as a friend—limited but not evil."

Now, at eighty-four, Virginia continues sharing her knowledge of Steinbeck at workshops and conferences. Not only Steinbeck, but many other literary figures have entered her life: Lincoln Steffens and his wife ("They were loads of fun and great conversationalists."), Ansel Adams ("I worked in his art gallery in San Francisco."), William Saroyan ("I loaned him money, which he paid back when he sold *The Daring Young Man on the Flying Trapeze*.), Robinson Jeffers ("We used to pass each other walking on the beach. After he realized I wouldn't intrude on his privacy, we started to speak."), Una Jeffers ("She invited me to a party at their house, and I couldn't stop looking at Salvador Dali's mustache or Tony Luhan's long black braids."), and Joseph Campbell ("I took a tour with him to the Greek Isles as my retirement reward. He certainly had a case on Carol Steinbeck.").

But most of all, Virginia is proud to have known all the Steinbeck wives—two of whom she liked. Here is how she saw them:

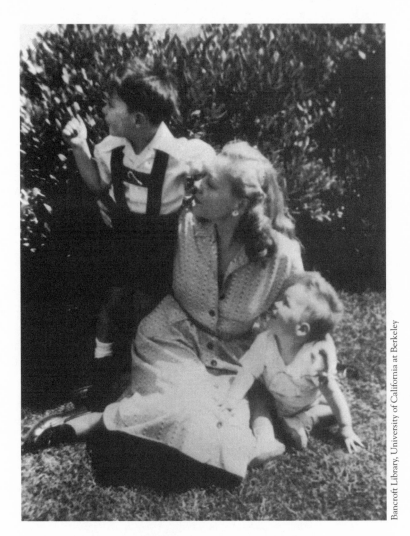

Gwen Steinbeck and sons John IV and Thom

Bancroft Library, University of California at Berkeley

Carol Steinbeck: "That marriage never would have lasted, even without Gwen. They were fighting even before they got married. Carol was very unhappy."

Gwen: "She wanted, and her mother even more so, to be married to a celebrity." She gave him two sons, but when she walked out she took all his reference material.

Elaine: "She made him comfortable with other people. Of the three, she was the only one who knew who she was before marriage. She recognized his talent, but he never allowed her to be his critic."

Virginia summed up Steinbeck's turbulent marital history by saying, "Steinbeck loved all his wives, but John's first love was always writing."

Ruth Duval, Los Gatos, California

After one of my lectures, Ruth Duval introduced herself to me. She had met Steinbeck and been part of his social circle when she was a young girl. Modestly, she asked if I'd be interested in her recollections. When I said yes, she invited me to her small old California home in the next town to mine, Los Gatos.

The home where the widowed Ruth lived with her son was small and warm and looked out at the Santa Cruz Mountains. She shared the same view that Steinbeck had while he was writing The Grapes of Wrath. *You could see the house where he lived from Ruth's back window.*

Ruth was very friendly and easy to interview. It was obvious that she treasured her girlhood memories of her involvement with Steinbeck, Doc, and the Lovejoys. She was especially close to the Lovejoys, and still seemed to regret their early deaths.

Ruth exhibited tremendous liveliness for a woman in her seventies. She attributed much of her energy to her many dancing activities. When I asked her to demonstrate, she was delighted to show some of her steps. We also had instant rapport because we both taught at community colleges, so we enjoyed comparing notes.

Ruth's observations are valuable, as the "kid sister" in the group

around Steinbeck, she spent a lot of her time observing. She gave us a
glimpse into those very early days when the young Steinbecks partied on
the Row. She also showed us Steinbeck as a friend and how he was
viewed by his friends at the time.

Ruth Duval was only a junior at U.C. Berkeley when she "got into
the Steinbeck thing" as she termed it. She became a regular at the
parties in Doc's lab despite her young age. "I was the baby of the
group," she laughed.

How did it all start? She was only sixteen when she went to
Alaska to live with her sister and brother-in-law, Margaret and
Bob Percy. He was an adventuring entrepreneur, reporter, an in-
ventor of a new paint thinner, and, at that time, a salmon fisher-
man. The year was 1936, and through Margaret and Bob she met
Richie and Tal Lovejoy, two of Steinbeck's closest friends. Tal's
father was the first Russian Orthodox bishop in Alaska. It was the
height of the Depression, and the Lovejoys, out of funds, had gone
home to Daddy. Ruth got a job with the local newspaper inter-
viewing people from the cruise ships.

Ruth and the Lovejoys became such good friends that it was
only natural for them to continue the friendship when they all got
back to California. Still low on funds, the Lovejoys moved into
Steinbeck's house in Pacific Grove. Then Richie went to work for
the *Monterey Peninsula Herald*, and Steinbeck continued to help
them financially. In 1939, when Steinbeck won the Pulitzer Prize,
he gave most of the money to the Lovejoys.

According to Ruth, the Lovejoys, in turn, gave emotional sup-
port to Steinbeck. "They often had him to dinner and were always
there for him. They were a big help to him when he had trouble
with Carol, and especially during their divorce," recalled Ruth.

The parties started when the Lovejoys told Ruth, "We want
you to meet a nice man on Cannery Row." That man was Doc
Ricketts. When Ruth first saw Doc's lab, it reminded her of her

mother's shed full of jams and jellies, only his jars were full of marine specimens.

Ruth recalled that Doc was a very funny but rather strange man, and his girlfriend was "a real kick." When I asked her to give me an example of Doc's behavior, she said, "We'd go into a bar and he'd say, 'You know what I'd like—a beer milkshake.' Then I'd be amazed that the bartender would make it for him."

She went on to say sadly, "None of us could believe it when his car got hit by the train. We thought, 'Doc, of all people!'"

And what were those famous parties like? Ruth said, "There was lots of good conversation. They'd talk about all sorts of things. They had great ideas, and no one was afraid to put them out there. I was just happy to be around all that creativity. There was lots of red wine, because everyone drank a lot in those days. Tal Lovejoy was a great Russian cook, and she used to bring some sort of Russian pizza for us to eat. I felt like I was in a fairyland."

What were her impressions of Steinbeck during those parties? Ruth recalled him as follows: "They were the best parties I ever attended. Nothing else came close to the fun we had. They all looked up to Steinbeck. He was the one who made things happen. They were all creative people, but they didn't seem jealous of his success. They really looked forward to his visits. Of course, I was totally in awe of him at the time. At the parties he always seemed like the person in charge."

Steinbeck's wife, Carol, produced a different and negative reaction in Ruth. "I didn't like her. She always made me feel as if she were putting me down."

Of all the party participants, Ruth's favorites were the Lovejoys. "They were the best people in the world and my favorites of all the people I've known. They were so different, so talented, and so nice. She was an artist and he was a writer, and they had three children, but one died. My husband, a San Jose State professor and a professional musician, also liked them. Each year

he was first trumpet for the Carmel Bach Festival, so we used to visit them every summer. They had a good life together, but unfortunately both of them died very young."

Ruth also collected Steinbeck first editions. She had a copy of *The Grapes of Wrath* signed by Steinbeck, but it was loaned to and lost by a neighbor, much to her regret. It was her favorite work of Steinbeck's.

Kalisa Moore, Monterey, California

If you get to Cannery Row, it's almost impossible not to meet Kalisa Moore. She is the Row's most influential and visible citizen. It's no wonder that the locals have dubbed her "Queen of the Row." Whenever I conducted a tour of Steinbeck Country, Kalisa's shop was a favorite stop.

On a good day you can see Kalisa walking up and down the Row chatting with store owners and tourists. Otherwise you can meet her while she dishes out delicious ice cream cones—the best on the Row— to her customers. She is the proprietor of a unique ice cream parlor across the street from the famous Monterey Bay Aquarium and Ed Ricketts's lab and right next door to the Wing Chong Building.

Kalisa's shop has a direct connection to Steinbeck, for it once housed the bordello called "La Ida's" in Cannery Row and Sweet Thursday. Luckily the basic structure has not been disturbed, but there have been changes. Several upstairs cubicles have been eliminated, and the black sink is gone. Downstairs a wall has been opened to create more room. The huge mahogany bar where the bartender saved leftover drinks for Mack and the boys has been sold. A large bust of Steinbeck has been saved by Kalisa, and the original La Ida Café windows have been retrieved from Mr. Yee. Kalisa says regretfully, "Unfortunately, I found out about the history of the place far too late."

After one of my tours Kalisa had some free time, so we sat down and chatted while I waited for my busload of tourists to return, and Kalisa filled me in on her colorful background. She took me on a personal guided tour of La Ida's and explained to me about its history and her own dreams for Cannery Row.

Kalisa came to Monterey from Europe in 1955. She opened the second gourmet restaurant on the Monterey Peninsula— Gallatin's was number one—using her own European recipes and specialties. The restaurant opened in the Thomas Wolfe House at 220 Oliver Street, but Kalisa opened at her present location on July 5, 1958. At that time La Ida's was a boarding house, so it needed some remodeling to function as a restaurant.

Almost from the beginning, La Ida's became a refuge for struggling writers and artists. "I was living on chicken wings until she started to feed me," laughed Michael Hemp, vice-president of the Cannery Row Foundation. There are photos all over the walls that attest to Kalisa's many friendships, including two pictures of Steinbeck and one of Ed Ricketts.

Gradually Kalisa also became the keeper of the Steinbeck legend and a key person in preserving the history of the Row. Over the years people from all over the world have come to La Ida's looking for the "real" Steinbeck. "A lot of them are students and teachers," explained Kalisa, "and they want to see for themselves the place he wrote about."

These visits have made Kalisa something of a legend herself. She has been featured in newspaper and magazine articles in such diverse places as Belgium, Germany, Africa, Turkey, and Greece. She has touched thousands of lives with her stories. The main remark she hears and treasures is, "We're glad you're still here. So much of it is gone or invisible. Everything else seems generic, but you are not."

Sometimes even the famous have appeared at Kalisa's door,

Cannery Row, 1947

The Pat Hathaway Collection

including Kim Novak, Betty White, Henry Miller, all the greats attracted by the Monterey Jazz Festival, politicians, and the rich and famous in general. John Travolta dropped in once looking for some chicken soup. But most of all Kalisa treasures the visits of students.

"We've got to let the young people know about Steinbeck and his works. Future generations need to learn about and appreciate him."

Did Kalisa ever meet Steinbeck, I asked? "Yes, just once," she said, "but I'll never forget it."

Here is how she remembers that eventful meeting:

"I met John Steinbeck on his last visit to the west coast," Kalisa told me. "The book *Travels with Charley* resulted from that trip. My Big Sur writer friend Dennis Murphy, who had written a book called *The Sergeant,* brought Steinbeck to my restaurant on Cannery Row.

"It was late in the evening and nobody was in the restaurant but we three. Before seating himself at the bar, John looked around the room, assessing his surroundings. He seemed pleased with what he saw, yet strangely quiet, subdued, somewhat depressed.

"John drank his wine in small gulps, eagerly accepting refills when I offered them. But he remained silent. Dennis preferred beer, and I had red wine.

"After a while John joined Dennis and me in conversation. I can't recall all we spoke of that evening, but I do remember him stating that Cannery Row had changed since the old days, and saying, 'No one will recognize me if I walk out into the street tonight.' Dennis and I heatedly objected to the remark, and we suggested walking over to the Steinbeck Theater, which had been named after him.

"John said something like he had gotten a special pass, but he didn't have it on him. Anyway, we walked over to the Steinbeck Theater. To our dismay, the street was empty—not a soul around.

We found that we could not enter the theater because a movie was showing. The glass doors were locked.

"We noticed a young man standing at the counter counting cash. I knocked on the door and introduced myself. The young man acknowledged me and said, 'I know where your restaurant is located.' There was a silent pause while the young man continued counting the cash.

"Then Dennis introduced himself, stating that he had written a book called *The Sergeant*, which had been made into a powerful movie—'You might have seen it.' The young man mumbled something about having seen the movie, and seemed irritated by our presence. We stood there in silence until John blurted out, 'I am John Steinbeck!'

"The young man stopped counting the cash, looked up, and said, 'Yes, sir, and I am the king of China!' And he went on counting the evening's receipts.

"We never found out what the young man thought of us, but we really didn't care. John had made his point.

"After that episode we walked back to the restaurant in silence and hung our noses in more red wine and beer."

At that time Kalisa asked Steinbeck if she could use some of his plays, as she was producing plays on the Row. She also asked if he would supply some answers for her many visitors. He agreed, and gave her the address of his attorneys. "I kept that card in my jewelry box for years," said Kalisa.

In 1970 Kalisa started the annual Steinbeck birthday party because "the spirit of Steinbeck always equals fun." Here is how she described the first one:

"I chose Steinbeck's favorite meal—spaghetti with meat sauce, French bread, a great salad, and red wine by the gallon. Of course, when we started, red wine was only thirty-nine cents a gallon. I used to charge only two dollars for the whole meal." The first guests were all the old friends of Steinbeck—Toby Street, Bruce

and Jean Ariss, George Robinson, and local fishermen and cannery workers.

The Steinbeck birthday has since become an annual event—with one exception. "One year I didn't organize it, and a group of media people arrived to cover the event," recalled Kalisa. "I was really embarrassed, but we've never missed a year since then."

The birthday party grew to such proportions that in recent years it has moved to several hotels and the Monterey Conference Center. For the past couple of years it has been "back home" again at La Ida's. The party now offers cuisine from the finest local restaurants, like the Sardine Factory, and entertainment like the Larry Hosford band, which plays songs inspired by Steinbeck's books, and actor Talen Thomas, who dresses up like Steinbeck and delivers deathless lines from his books.

"Sometimes it's big fun, and sometimes it's small," said Kalisa. It's always held on Steinbeck's birthday, February 27. Kalisa pointed to a proclamation by the California Assembly, which has designated the day a historical event "in perpetuity" thanks to her efforts.

The Steinbeck birthday party has been so successful that it is now followed by the Doc Ricketts birthday party on May 14. This was begun in 1999, the centennial of Ricketts's birth. It attracted many of Ricketts's old friends and admirers, and was celebrated at his lab across the street from La Ida's. It, too, promises to become an annual event.

Kalisa constantly struggles to preserve the old against the advent of the new discount stores, boutiques, and restaurants. Cannery Row (or "the Street," as it is called by the locals) is still the most famous street in the United States. More famous than Broadway or Wall Street? Yes, indeed: because Steinbeck's books have been translated into so many languages that they outsell the Bible. Even Disneyland built a replica of Cannery Row in its amusement park in Anaheim.

To aid her in her everlasting struggle to preserve Cannery Row, Kalisa helped start the Cannery Row Foundation in 1972, and it was incorporated on February 17, 1983. It is the guiding light behind the birthday parties, the creation of the Ricketts Memorial at the site of his crash at Drake and Wave streets, the annual cannery workers' reunion, the reunion of skippers of the old fishing fleet, and the tributes to the early Chinese settlers on the Row. The foundation was dormant for a few years, but was revitalized in 1993 and is now planning for the Steinbeck centennial in 2002. The foundation is so respected that it is rumored that no one makes a decision in Monterey without first consulting Kalisa Moore (president) or Michael Hemp (vice-president).

It was Hemp who best summed up for me Kalisa's role in the Steinbeck legend: "Her devotion to Steinbeck and the history of Cannery Row has come at a real cost. She has taken time and energy away from her own business to make this contribution. Her persistence has kept it alive. She has carried the torch of Steinbeck's life and works, and is the heart and soul of Cannery Row."

Richard (Dick) Shaw,
Cathedral City, California

I attended the Fourth International Steinbeck Congress in March 1997. On Wednesday, Thursday, and Friday, the sessions were held on the campus of San Jose State University. On Friday afternoon many of us drove down to Monterey for the weekend portion of the conference. The Saturday morning session featured a panel of fishermen and old cannery workers. Dick Shaw, a grandson of Flora Woods, the well-publicized madam of "Cannery Row," proved to be one of the most memorable speakers on the panel. Afterwards I introduced myself, and he was most open and gracious.

He gave me his card, which bore an address near Palm Springs. He mentioned that he was heading there for a vacation with his family right after the conference. I planned to be there at the same time for my Easter vacation from school. We compared notes on the local golf courses, and he agreed to let me call him for an interview.

I called him the following Monday, and he agreed to talk to me after he finished his morning golf game with his son. He said that afternoon would be perfect because it was the one hiatus in his week of entertaining five visiting grandchildren. He gave my husband directions, and we drove across the desert to Cathedral City. It was easy to find him because the sign "Outdoor Resorts" hung across the highway as he had

promised. It signaled the entrance to one of the largest and most beauti-
ful RV resorts in the country. We picked up a parking ticket at the front
gate and then drove past swimming pools, top-of-the-line RVs, a coun-
try club, and a manicured golf course, and then we reached Shaw's spot.

Shaw was waiting for us, clad in shorts and a golf sweater. His tan,
lithe, athletic build belied his seventy-eight years. He showed us his el-
egant trailer home and spoke with pride of this park, where he spent
about six months of every year. Then we settled down on his patio for
an interview that lasted three hours—but seemed like three minutes.

What was it like to be Flora Woods's grandson? This question still
brought tears and emotional reaction from Dick Shaw, who was
almost an octogenarian.

His first inkling about his grandmother's occupation came
when he was seven years old because, as he said, "My folks never
discussed it. During their whole lives, they never mentioned a
word about it." As a second grader he was totally unprepared for
the taunt that came from a fellow classmate: "Your grandma is
Flora Woods. She runs a whorehouse."

"I didn't even know what a whorehouse was," admitted Shaw,
"but I knew it was some kind of an insult, so I belted him. We
fought, and I came home with a black eye. When my mother asked
me why I was fighting, I was too ashamed and afraid to tell her."

Later he realized that the classmate had been right, but he
could never discuss it at home. His mother, Nettie Woods, was one
of Flora's two daughters. The other daughter was Ida Woods. Al-
though the sisters remained friends, there was no communication
between Flora and Nettie due to a family argument.

As he grew, Shaw admitted, he continued to wonder about
Flora and what she looked like. He only visited Flora three times
during his lifetime.

This is how he remembered the Lone Star, his grandmother's
whorehouse, which would be immortalized later in the novels of

Steinbeck. "There was a central hallway and about ten rooms which extended all the way back to the railroad tracks. There was a dance floor, and Flora's room was behind the bar. In the beginning she wanted to start a restaurant, so food was served there. The establishment was extremely clean, and the girls were first-class women. There were no drugs, and the women never approached a man first. They would never try to rob him of his money. Of course, everything for Flora was strictly payola. In order to run an illegal establishment, she had to pay off everyone."

Shaw was brought up in a family of eight, and money was always scarce. At the age of seventeen he needed an extra dollar to go to a dance, so he decided to borrow it from his affluent grandmother, Flora. "She said to me, 'You can have the dollar, but you'll have to pay interest on it. You'll owe me one dollar and twenty-five cents.'" That infuriated the young Shaw, who stormed out of the Lone Star without the dollar.

In the last years of her life, Flora fell on hard times, and Shaw admitted that he felt sorry for her. "She was broke and living in a small rented room over by the lake. Her fourth and last husband had cleaned her out. She had bought him a taxi cab business, but he wasn't a businessman, so he mismanaged it. She was ill, but I brought my family over to meet her and she smiled and seemed pleased. I was out of town at the time of her death, and I understand she didn't even leave enough money for her funeral. She was completely broke at the time of her death. She wasn't a bad woman. She never did harm to anyone."

Having Flora as his grandmother also led to certain "family secrets." His mother, Nettie, had a daughter, Dolly, before her marriage to his father. Shaw never had contact with this half-sister, who was brought up by Flora. Later in life he learned that Dolly had moved to Lake Shasta, where she opened her own whorehouse.

There was another strange story in connection with his sister

Flora Woods

The Pat Hathaway Collection

Dolores, who, agewise, was in the middle of the pack. Early in Dolores's life Flora and Nettie fought for custody of her. After a very public trial, the judge ruled that neither woman should raise her and placed her in a foster home.

"We were so poor," recalled Shaw, "that actually she lived better there than the rest of us at home. She was married three or four times. Once, between husbands, she came back to town and I gave her a job in my factory. Later she moved to Las Vegas and died of cancer at the age of fifty-three."

At the age of sixteen Shaw dropped out of Monterey High School and went to work in a cannery. He slept in a room over the cannery, which was next to Doc Ricketts's lab. That gave him a first-hand view of Doc and Steinbeck in their heyday. This is how he remembered it:

"Doc and Steinbeck were regular guys. They were always nice and sociable—even to me, although I was a younger guy. They had great senses of humor and were real characters. What an outlook! They never worried about tomorrow. They were really having a good time, really joyful. I never heard an argument coming out of that lab."

Most of all Shaw remembers their parties. "They would have big parties about four or five times a week. Steinbeck would supply the booze. I would be jealous because I was too young to be invited, and also mad because I had to get up to go to work the next day. As soon as the establishments closed at 2 A.M. I could see all the girls walking over to the party at Doc's lab. Then everyone would leave about 6 A.M. the next morning."

Shaw also shed light on Steinbeck's early creativity. "No one ever mentions that Steinbeck actually worked in the canneries himself. He used to go around talking to everyone, and so he got all his stories directly.

"In the canneries he worked with some of the Okies. They were hard workers, but they were scorned by everyone. They were

really an abused lot. He was dead right about the way he wrote about them in *The Grapes of Wrath*."

Shaw's apartment was situated where he could get an interesting view of the Lone Star's clientele. Some customers who wanted to protect their privacy used to slip in the back way by the railroad tracks. "I used to see some of my relatives—the wealthy ones—go in that way," laughed Shaw.

After dropping out of school, Shaw said, he got his education "on the golf courses and in the canneries." At the age of eight or nine he started to "scratch for a living" to help his parents—picking berries, selling pine cones, and caddying on the area's five golf courses. When they moved to a ranch in the Carmel Valley, Shaw recalls, "If I didn't shoot some rabbits, there wouldn't be any Sunday dinners." Out of these struggles emerged a desire to "make something of myself."

He started cutting sharks' livers out for the reduction plants. Next he started working in the canneries on the Row. He owned a service station, held a job servicing machines for Standard Oil Company, worked in the shipyards, did a stint as an army instructor during World War II, farmed, and then took a mechanic's job for Western Frozen Foods. He rose to superintendent, then manager, then general manager, and finally partnership. He worked there for twenty-one years before starting his own company, the Richard A. Shaw Company, Inc., which he ran for seventeen years. His company was the largest one in California, boasting over fifty-four different vegetable items, and sold to all the major chains. "That means I spent fifty-one years in the food-processing industry before I retired at seventy," Shaw said proudly.

Despite his childhood of extreme poverty, Shaw did not seem to resent Flora. He seemed to feel that she probably helped his parents behind the scenes. Flora always had a reputation for helping people who were down on their luck. "For several years my parents had a chain of stores called Anette's Shops," recalled

Shaw. "They were wiped out by the Depression. But my folks had no way to get the money to get started in business. I think it had to be Flora's money."

We wondered aloud about how proud Flora might have been about her grandson's success. "No," he demurred. "She wasn't that kind of woman. It was as if she were on some kind of pedestal—not focused on the family." Shaw learned a lesson from that, too. "My family and keeping them close—five children and thirteen grandchildren—has been my main objective," said Shaw simply.

Despite his long life of achievements, Shaw could still remember his early days on the Row when Doc and Steinbeck were there. "It was a stinking place. There was fish everywhere. The Chinese had fish drying on lines. Even Wing Chong had some in his shop. I used to soak in a tub hoping to get that awful odor out.

"Of course a school of sardines was a beautiful thing to see. They could illuminate the whole bay. When the purse seiners came in they tripled the tonnage of the hauls of the fish. No wonder they depleted the sardines.

"The other thing was the grueling hard work. I used to make fifteen cents an hour. One week I worked one hundred and fifty-five hours. I earned twenty-two dollars—twenty dollars for my parents and two dollars for me, and that was big money.

"Then there was the terrible noise. I still have nerve damage to my hearing from those days.

"People have asked me how I liked the book *Cannery Row*. Frankly, I've never read it. I don't have to. I lived it!"

Louise Archdeacon Travis, Lake Havasu, Arizona

I had to travel the farthest for my interview with Louise Archdeacon Travis. When I was working with Sparky Enea on my book With Steinbeck in the Sea of Cortez, *he often spoke fondly of "Tex" Travis and their days together on the trip to the Sea of Cortez. He regretted that Tex had retired so far away, in Lake Havasu, Arizona—too far away for the old friends to communicate. When Tex died, Sparky was incensed that the* Monterey Peninsula Herald *did not carry an obituary for someone he considered an important member of a famous and historic expedition.*

Mentally, I tucked away the fact that Tex's widow might still live in Lake Havasu. A few years later, while planning a gambling trip to Laughlin, I thought of her again. Just for the fun of it, I called long distance information, and they located her right away. She sounded delightful and invited me to visit her.

My husband and I hired a car and drove about a hundred miles across the dusty, barren landscape between Lake Havasu and Laughlin, Nevada. We stopped at the famous tourist attraction of London Bridge to alleviate the boredom of the trip. Then we were confronted with a seemingly endless series of retirement communities that make up Lake Havasu.

Louise's house was different. It was located on a side street in a nice neighborhood, and was bright and cheerful and immaculately kept. Louise lived there with her daughter, Patricia. They greeted us warmly and enjoyed showing us Louise's treasured possessions, including those connected with the trip to the Sea of Cortez.

Despite her advanced age and widowhood, Louise was full of life and joy. She laughed often and delighted in telling us her reminiscences of her husband and the famous trip. Obviously, they had had a good life together enjoying their family and the life of a fisherman. For Tex, the high point of that life had been the trip with Steinbeck. Throughout his lifetime he re-told the story often, and obviously Louise had never tired of hearing it. She, in turn, was delighted to find in me a new audience for the story.

Shortly after our visit, Louise and Patricia moved to Laguna Hills, California, to be near to the rest of their family. Louise did so with mixed feelings—happy to be near the rest of the family, but sad to leave the home where she and Tex had shared a happy retirement. She wanted to continue our friendship because of the Steinbeck connection and what it had meant to her husband. We exchanged many phone calls and letters.

"My husband and Steinbeck had a lot of common interests," recalled Mrs. Travis, "so they really enjoyed sharing wheel watches on the trip. He told me that they used to talk for hours on end."

The friendship deepened to the extent that they planned to buy a boat together in the future. Steinbeck wanted Hall to be the skipper when he and his friends wanted to go on excursions during his visits to Monterey. Unfortunately, World War II intervened and Steinbeck went overseas as a war correspondent, never to return to the area. Tex and Louise became engaged in January, and the crew left on the famous voyage to the Sea of Cortez in March. As an engaged man, Tex did not go ashore to participate in the wild escapades of Sparky and Tiny. However, Louise did share a delicious bit of gossip about the trip: "He [Tex] told me that

Tiny and Carol Steinbeck were always going off alone together. No one could ever find them."

In San Diego, Spencer Tracy and John Ford came aboard to visit and party with the Steinbeck expedition. They had a black chauffeur who asked, "Is it okay if I come aboard?" Louise says that Tex, even though reared as a Texan, was the first to say, "Come on down."

Steinbeck and Tex developed such a close friendship that they even swapped clothes. Steinbeck coveted Tex's seafaring clothes; in exchange, Tex would wind up with some of Steinbeck's silk shirts.

Although Tex emerged as one of the most serious members of the famous expedition, he still earned some comments in Steinbeck's famous book. For example, he hated to take his turn at washing dishes, so he pretended to be busy in the engine room when his turn came. The crew got disgusted one night, so they piled all the dirty dishes in his bunk. Needless to say, that cured him.

"It was funny, because he never minded doing dishes for me," said Louise. "When I asked him about it, he said that it just was unpleasant to wash dishes on a rolling boat."

The most memorable part of the trip for Tex was his constant trouble with the outboard motor on the little skiff, nicknamed the *Hansen Sea Cow* by Steinbeck, used for taking the crew ashore. It constantly broke down, much to the aggravation of the crew and to the amusement of Steinbeck, who wrote about it extensively in *The Log from the Sea of Cortez*. Tex's daughter, Patricia, remembered that whenever the outboard motor was mentioned her father would say, "I hated that sonofabitch. It was always a piece of shit."

After the trip ended, Tex continued to meet with Steinbeck. Louise said that "There were some wild stag parties up at his Los Gatos home, and he would invite the whole crew to come up.

They also used to meet him locally at a bar called My Attic, where reporters used to go to drink and play cards. Steinbeck was sort of a social recluse, but he liked to be with everyday people."

Louise also visited Doc Ricketts, and had some vivid recollections of him. "He used to come to the house dressed in leggings and boots. He was the only person I ever saw dressed that way."

In his lab, she remembered, "There were hundreds of jars and specimens everywhere. The smell of formaldehyde was very strong. Cats got really scarce in Monterey because Doc would give the kids twenty-five cents for each one they brought in."

Doc's accidental death after his car was hit by the Del Monte Express still saddened Louise. "None of us could believe it. Medically, he used to take care of Flora Woods' girls and examine them. At Christmas and Thanksgiving Flora was the first one there to load the pick-ups with turkeys for the poor families. Anyway, none of us could understand Doc's accident, and we all felt bad. What a nice man!"

Louise still maintained a close friendship with Captain Tony Berry, the skipper of the *Western Flyer*. His first wife, Rose, was responsible for introducing Tex and Louise on a blind date. When they were married, October 13, a year following the trip to the Sea of Cortez, in the royal presidio chapel, Rose was the matron of honor and Captain Berry was the best man—by proxy, due to a leg injury. Later the Berrys became the godparents of Patricia Travis.

Tex was a professional fisherman for over forty years. When the sardines left Monterey, the Travises moved south to San Pedro, where Tex fished again. Soon he was the co-owner of a fishing boat called the *Comet*. They had three children, Patricia Travis, Gilbert Travis, and Ida Beverly, all of Laguna Hills; six grandchildren, and three great-grandchildren. For eighteen years after retirement, until his death from cancer, Tex and Louise lived in Lake Havasu City, Arizona.

Today, Louise still treasures some artifacts from Steinbeck's

time. She showed me an autographed copy of *The Log from the Sea of Cortez*, a crystal bowl that was a wedding gift from the Steinbecks, and an ice bucket that was a wedding gift from Doc Ricketts. A turtle shell and bull horns were souvenirs Tex brought back from Mexico. There was also a framed card from the Steinbecks, "With sincere wishes for your happiness, John and Carol Steinbeck."

Throughout their life, Tex told Louise stories about their famous trip. Louise said that he always called it "the trip of a lifetime," in which Steinbeck was always "just one of the boys."

William (Bill) Thomas, Saratoga, California

If I had to travel a long way to meet Louise Travis, Bill Thomas turned out to be amazingly close. He and his wife, Martha, lived on Pierce Road in Saratoga, a few streets away from my home, close enough to be considered a neighbor. In order to interview him, my husband and I simply rode over on our bikes.

How did I learn about him? When I gave my lecture at the Saratoga Senior Center, Thomas was not present, but when I asked if anyone had known Steinbeck, the other members volunteered his name. When I called him up, he graciously invited me over for an interview.

Bill and Martha greeted us very warmly. They told us all about their lives, their family, and their travels. Their home was filled with early-California antiques, and they explained the history of each piece, especially its connection to Monterey and Steinbeck's time there.

The Thomases also showed us many treasured paintings from that era. Thomas told us a lot about the history of China Point. He seemed especially intrigued by—and ashamed of—the way the Chinese population had been treated in Monterey.

Obviously he was very proud of his parents' connection to Steinbeck and all the people Steinbeck knew and wrote about. There was a definite kinship between Thomas and Steinbeck.

Part of the interview took place in the front yard. We sat and chatted in the shade of the old trees, surrounded by the Thomases' garden. Afterwards Martha served us cookies and tea in their dining room. Like Steinbeck, the Thomases enjoyed traveling around the world. Because of their extensive camping, they identified closely with Steinbeck's adventures in Travels with Charley. *Bill Thomas also seemed to have another thing in common with Steinbeck: no matter how far and wide each man traveled, his heart and fondest memories were forever centered in Monterey County.*

"You couldn't get a more authentic record of the place than in Steinbeck's novels," said Bill Thomas, who was younger than Steinbeck but knew the same places and people Steinbeck knew.

"We lived right across Washington Park, opposite the Steinbeck home in Pacific Grove," he explained. "That's the place where he always came when he was tired or troubled. He loved the area, and I feel the same way. I've traveled all around the world, and I can't think of a nicer place to live than the Monterey Peninsula."

Thomas corroborated what many others have suspected about Steinbeck. "He wrote about real places and real people. They weren't just products of a good imagination. Of course, he made them more interesting by the use of his great writing skills."

Thomas remembered a personal encounter with one of Steinbeck's characters: "He was the guy with the dogs in *Tortilla Flat*. We called him "Shakey," and he was sort of a hermit who lived in a squatter's home. A friend of mine and I had bought a sailboat, but it had a square sail, so after we got to our destination we couldn't tack and return home. We needed his cart so my mother could tow us. We went up to Huckleberry Hill and all the dogs came running out to meet us, but they were friendly and he sold the cart to us."

Thomas's father knew all of Steinbeck's characters because he

was the manager of the Union Supply Lumber Company located on Cannery Row. "Dad knew and liked Steinbeck and Doc. He also knew Flora. There was gossip all over town about Flora's place. It was a family joke that when she needed alterations on her place, Dad had to go over to estimate for them what lumber they needed for the work."

The Thomas family was also close to another Steinbeck friend, Ray Atkins. "People in the area remember Steinbeck as a great writer, but also as a great drinker. We were friends with Ray Atkins, Steinbeck's drinking buddy. They'd get together with a bunch of other men and go to afterhours places to drink and talk. I'm sure that Steinbeck got a lot of story ideas from these sessions. Years later we stopped in Montana and visited Ray, who had moved to a ranch. He still enjoyed telling stories about the cama-raderie he and Steinbeck had shared."

Most of all, Bill Thomas shared a love of the same places that Steinbeck loved. Like Steinbeck, he loved the Salinas River. "It's such a deep river and so muddy that it is home to fish without eyes. It's so deep that I understood why Steinbeck's grandfather, who lived beside it, had trouble digging a well. A friend of mother's, Anne Fisher, wrote a book about it. Another friend of mother's was Doc Rickett's wife. She and mother were in the P.T.A. together."

Another place of interest to both men was the Corral de Tierra (the setting for *Pastures of Heaven*), located on the road between Salinas and Monterey. Like Steinbeck, Bill Thomas used to walk all over this area, and he loved the rock formations that Steinbeck called "The Castle," the setting for his only mystery story, "The Murder."

For three years Bill Thomas taught at Monterey Peninsula College, and during that time he discovered Prunedale outside of Salinas, which offers sun instead of the notorious fog of the Monterey Peninsula. "Now we own twelve acres that overlook all

of the places Steinbeck put in his novels—the Gabilan Mountains, the Salinas Valley, Monterey Bay, Fremont's Peak, El Toro, Loma Prieta, and the Elkhorn Slough."

In the 20s and 30s, he remembered, Monterey was referred to as "The Circle of Enchantment." He also remembered that Pacific Grove was known at that time as Church Town and that "the odor of sardines was so strong that I remember a carpenter climbing off his ladder and quitting the job because of it." During that time local people, according to Thomas, had a funny way of describing the place: "Carmel by the Sea, Pacific Grove by God, and Monterey by the Smell."

In later years, Bill and Martha Thomas often had lunch at the Steinbeck House in Salinas. It reminded Bill of the hostility of the local people toward Steinbeck. "They were really chagrined by the stories he told. They didn't like him a bit, because he told the truth about the locals. They hated him because he drew on reality for his writings—local people and places. Of course, now that he's recognized as one of America's finest writers, a cottage industry about him has sprung up."

One of the Thomases' favorite books was *Travels with Charley* because, like Steinbeck, they traveled around the country in a camper: "Martha is the wagonmaster of the American Clipper Association, and often we start our trips in King City, long associated with Steinbeck's novels. We love the story of a pail of sloshing water as his washing machine, because we've done that ourselves."

Bill Thomas's hobby is researching and writing about local history. One of his favorite treasures is a half-burnt wood carving of a Chinese junk rescued from the infamous burning of the Chinese settlement, China Point, a place made famous in Steinbeck's novels. "They say the fire wasn't an accident," he said knowingly.

His own interest in history is why he appreciates the writing

of Steinbeck so much, because, as he said, "Without Steinbeck, the world would not have such a record of the life and feelings of the people of California. He left us an authentic record of a place, a time, and a people."

Jake Clemens Stock, Monterey, California

Meeting Jake Stock was a total—and wonderful—fluke. It all started with a one-day fishing trip with Sam's Fleet in Monterey harbor. On a hunch I asked one of the fishermen who baited our lines if he knew anyone left in Monterey who had known Steinbeck. He thought for a minute, and then he said, "There was a guy who used to drop into the bar where I go who claimed to know him. He's old, but I think he's still around. His name is Jake Stock."

It was easy to locate Stock in the Monterey phone book, and he was receptive to an interview. When I called for directions, a strong voice answered, "Go to Casa Verde and turn left. Go left on Montecito and, after you cross Ramona, turn right into John Street. You'll recognize my house because there's a cement wall in front of it that I built myself. It's the only one like it on the street."

It was a small house, similar to the rest of the homes on the street, in an old section of Monterey. He was right about the cement wall. It did set his home apart. He met us at the door in his wheelchair with his pet cat on his lap.

Stock lived in the family homestead with one of his daughters. He pointed with pride to a family picture of his nine children, all but one of whom are still alive. He bemoaned the loss of his walking ability, but

otherwise he seemed to enjoy life and was very lively. With great pride he showed me his newspaper clippings and was proud that he had been Citizen of the Year in Monterey in 1982. His "day job" was stone masonry, and he was proud that there were examples of it all over the Monterey Peninsula.

But it was obvious that Stock's real love was music. His wife was a singer, and he had organized the band "Abalone Stompers." In a musical career that spanned fifty years, he played with many of the jazz greats who visited the Monterey Peninsula. He picked up his horn sadly and tried to play, but he gave up, saying, "It's no use. I haven't got the wind to play anymore." Instead we listened to some of his favorite jazz records. At the end of the interview he gave me a tape produced by his band.

Although Stock's meeting with Steinbeck was brief, it was memorable. It shows Steinbeck's love of jazz and how it was a link for him between his old life on the east coast and his new life on the west coast.

"It was in 1942 and we were playing a gig at the old San Carlos Hotel when I met John Steinbeck," recalled "Papa" Jake Stock. "This big, tall guy loomed over me while I was picking out tunes for the second half. So I said to him, 'Any special tune you'd like to hear? Let me play it for you.'"

"'No, son,' he answered sadly. 'You wouldn't understand. I live in New York and my home away from home is the Condon Club. I can't believe that I climbed on an airplane and eight hours later, I'm here and listening to the same kind of music, the same beautiful sounds.'"

Stock, who had earned his own local fame playing "mostly clarinet" and some sax with the Abalone Stompers, felt an instant kinship with Steinbeck. They liked the same kind of music.

Then Stock, now aged eighty-five, brought out one of his most prized possessions, a book published by St. Martin's Press in 1973 called *Eddie Condon's Scrapbook of Jazz*. It was autographed by

Condon and it contained a two-page foreword by Steinbeck, one of Condon's greatest fans.

Many years later, while playing in Salinas during the Steinbeck Festival, Stock met John Steinbeck IV, the writer's son. In one of those strange twists of fate, Stock mentioned the meeting with his father. The son laughed in recognition and told Stock, "Yeah, it was his favorite. You don't know how many times I had to drag my old man drunk out of the Condon Club."

Stock also knew Flora Woods, the famous Cannery Row madam who became Dora Flood in Steinbeck's novels. He also knew several of the other characters who found their way into Steinbeck's books. He and his fellow musicians used to go to her well-known whorehouse, the old Lone Star on Cannery Row, for jam sessions. When their regular jobs finished around midnight they would head to Flora's for jam sessions that lasted until the early hours of the morning. Stock's wife, Grace, would often go down to accompany them on the piano.

What was Flora like? "She was an extremely quiet person, heavily built, very unassuming," remembered Stock. "We were always welcome to come down on slow nights. If the fishermen had come in with a big catch, or if it was the soldiers' pay night, she'd tell us, 'Not tonight.'"

Stock also knew Ed Ricketts. He described Ricketts as a loner who had endeared himself to Flora's girls by doing them many little favors. They, in turn, according to Stock, "were always bringing food over to Doc, baking little trays of cookies and things like that."

Frank Wright, Carmel, California

Ed Ricketts, the model for Steinbeck's "Doc" in Cannery Row *and* Sweet Thursday, *would have been 100 years old on May 14, 1999. To honor the occasion and his memory, members of the Cannery Row Foundation decided to have a party in the old tradition of Ricketts's lab—good friends, local characters, entertainment, lots of wine, and plenty of canned sardines. The dinner buffet, prepared by Kalisa Moore, included salmon, salad, vegetables, goulash, and a chocolate cake in the shape of the lab.*

During the social hour, I found myself on the back porch of the lab with one of Ricketts's old army buddies and a member of the group that later purchased the lab, Frank Wright ("no relation to Frank Lloyd Wright," he disclaimed, "even though we kept a picture of him in the lab"). When I asked if I could interview him, he said with a cynical laugh, "I'm eighty years old, I've had a successful career in banking, and all that anybody cares about is that I knew Ed Ricketts."

"I never met Steinbeck," Wright told me in our interview, "but it's true that he was Ed's closest friend. Once he came to visit, but I was out of town, so I missed him. Steinbeck had a great talent, but I think his conversations with Ed made him great. I still can't read

Steinbeck's history of the class of 1919 in the Salinas High School yearbook of that time without getting tears in my eyes when I realize that this eighteen-year-old kid had the style and grace that would make him a great writer."

Wright also had some interesting background information on another of Steinbeck's novels. "The history of who was the great madam in *East of Eden* was and should remain somewhat of a mystery. But the truth of the matter is that she was never 'one of the girls,' but instead a very proper young businesswoman in San Francisco. A certain Salinas businessman hired her to be his bookkeeper for his various business interests. She came to town, got the bookkeeping organized, and ultimately married the boss.

"One of [that businessman's] properties was a bordello, and as you might expect, it was a profitable business—not a fancy business, but a successful one. It was called the Diamond Hotel, and was at the corner of North Main Street and the San Juan Grade road. Steinbeck knew about it, and fabricated a story of total fiction. This illustrates how Steinbeck could take a hint of a good story and manufacture a whole book out of it. As descendants of hers are still living, it is not the time to reveal her precise identity. But I know!"

After this startling half a revelation we sat watching the sun set behind the large tanks that used to house Ricketts's marine biology specimens. The night was clear, the waves were lapping at the shore, and the lovely scene reminded Wright of his wedding at the lab.

"We didn't want to get married in the bar at the lab, so we just came out here and stood at the wall with our backs to the ocean. We were married by a justice of the peace, and we had only one witness, a sculptor. It was the first day of spring, and the weather was beautiful."

How had Wright met Ricketts, I asked?

"Ed and I met in the Army during World War II," he explained.

"I was drafted on September 11, 1942, and arrived by train from Berkeley at a reception center in the Monterey presidio. Ed was checking our urine samples, and sometimes he'd work all night to make sure his results were correct. Once he even discovered a case of leprosy. He never used the 'sink test' so common in the Army at that time. He performed every urinalysis as it was supposed to be done."

The friendship grew when Ricketts would invite Wright over for a *haliotis* (abalone) dinner at the lab. "The abalone would be freshly caught that day. He had a little mallet to pound them before putting them into egg batter. On the way to the lab we'd stop at Wing Chong's for some Burgermeister beer, double size, for thirty-five cents. Wing Chong had steely black eyes and didn't want people wandering around the store, for fear of shoplifting. It was the only store I knew that had firecrackers, Halloween masks, and Christmas decorations on sale all year round."

The parties at the lab were even more memorable than the dinners. "Everyone loved to go and see Ed, and he always seemed glad to see us—even if twenty-five people decided to just drop in. He would share whatever food or drink he had with us. There was always an amazing mix of people. I remember listening to two couples discuss their plans to swap wives for the purpose of having babies. This was shocking to a straightlaced kid from Berkeley."

Despite this open-door policy, lab society was not universally open. "No ladies were allowed to join the lab," Wright laughed. "None ever actually tried to join. Of course, we had many lovely ladies present at our parties."

Did anyone ever call Ricketts "Doc," I asked?

"No," said Wright. "We never called him that. That was something that the children on the Row called him. They would play in the dirt and get impetigo and go to Ed for help. He would smear their lesions with cotton swabs of gentian violet to cure them. So 'Doc' was the name the kids gave him."

After the birthday dinner that evening, Wright made some further observations on the lab. He pointed out to the guests where Ricketts had installed the speaker for his famous phonograph. He pointed to a wooden coffee table and said, "Ed's wife, Nan, built this coffee table. We used to make home-made onion soup, and we'd eat it there. The back room was divided into two bedrooms, and there were always guests. The sheets were never changed, so it was all pretty friendly."

Wright was one of the fourteen men who formed a corporation to buy the lab property in 1957 from Harlan Watkins, who had bought and occupied the lab after Ed Ricketts's death. The group held weekly parties there on Wednesday nights. As Wright told me, "It's impossible to give a bad party here."

Recently the members of this corporation realized that they were getting old and facing their own mortality, and they sold the lab to the City of Monterey. The city took apart the lab, numbered board by numbered board, and earthquake-proofed it. There are still restrictions on the deed: the remaining members of the corporation will control access to the lab until 2008.

That evening in May 1999, as Steinbeck's words filled the dimly lit lab we were transported back to the era of the lab's famous parties—food, drink, interesting guests, and great conversation. Frank Wright's final words summed up this fine celebration of Ed Ricketts: "The lab is a happy place full of memories. It's required. As Steinbeck said in *Sweet Thursday*, just because it didn't happen doesn't mean it isn't so. Or something like that."

Los Gatos

1936-1941

Horace Bristol, Los Gatos, California

At the Fourth International Steinbeck Conference, I was invited to sell my books, as were other authors on Steinbeck. We were all assigned to a certain room, and my table was next to an attractive young woman who was selling photos. It took me a little while to realize that I was looking at photos of migrant workers. The photos were in black and white, and showed the migrants and the camp buildings. To me they were as striking as the famous photos by Dorothea Lange.

Startled, I asked the young woman who the photographer was. "Horace Bristol," she said with great pride and warmth. I pleaded ignorance and she introduced herself as Donna Granata of "The Focus on the Masters," a program at the Brooks Institute in Santa Barbara that documents the work of contemporary artists. She said that as an artist she had always admired Bristol's work. She was astonished to find him in the phone book. When she told him of the project, he became its first donor. From that encounter they had become close friends because, as she said, "He is the most gentle and loving man I've ever met. I just love to sit and listen to his stories."

Naturally, I asked her if Bristol had ever met John Steinbeck. Imagine my surprise when she said, "Of course. They traveled to the migrant camps and worked together." My next step was to purchase some

*pictures and get Bristol's phone number. When I told Donna of my plan
to interview him next summer, she said, "You had better hurry. Horace
has a bad heart. Don't wait too long."*

*She was right. When I called Bristol's home a week later, I was told
that he had already gone to the Ojai Community Hospital. Donna told
me sadly that he was not expected ever to leave the hospital, but that he
was anxious to speak with me. Thus I had my most dramatic interview
for this book, by phone, which turned out to be an actual deathbed inter-
view. When I called the hospital on the night of May 29, 1997, Bristol
politely requested that I call back the next morning because "I have a lot
more strength in the mornings." Early next morning, armed with my
notepad and tape recorder, I asked for Room 12 and Bristol, sounding
only slightly stronger, graciously gave me the following interview.*

*Despite his weakened condition Bristol was anxious to share his
memories of sixty years ago. They seemed extremely vivid, and his voice
became stronger as the interview progressed. Perhaps he realized that his
memories were an important part of the Steinbeck story—a part of his-
tory that, if not recorded now, might be lost forever.*

I wondered how Bristol's involvement with Steinbeck ever got
started. "In the thirties I was working as a photographer for *Life*
magazine. Dorothea Lange and her husband were my friends, and
I went with them to photograph some migrant camps near Sacra-
mento. I told my editor at *Life* about it, but he wasn't interested.
He just wanted me to photograph pretty girls. I had an idea for a
big picture book on the migrants, but I needed a writer, so I
thought of Steinbeck and called him up. He invited me to come
down to his house in Los Gatos for the weekend to talk to him. He
agreed, so we set out on Monday."

How was it to travel with Steinbeck? Bristol remembered
fondly, "Steinbeck put everyone at the same level. He just talked
to the migrant workers in a simple, friendly way. He was very good
at that."

Bristol and Steinbeck traveled in a Buick stationwagon. "It was rather embarrassing. We must have looked like creatures from a different planet to the migrant workers. We filled up the car with cheap meats and lots of beans. It was our gift to the migrants and also our way of introduction. We would ask them to cook it up because we were hungry too."

According to Bristol there was also a dark side to Steinbeck. "He was a very silent person and never discussed politics or his writing. When we got to a hotel, he wouldn't sign the register. He explained to me that he didn't want anyone to know where he was. He was afraid that the Associated Farmers would beat him up or kill him. When people ask me if he was a communist, I have to say, 'No more than the average intellectual of the time.'"

On the way home Steinbeck decided to show another side of his character. Here is the way Bristol recalled his intimate glimpse of Doc Ricketts and his life on Cannery Row.

"John had said to me, 'Why don't we stop off and spend the night with Doc Ricketts in Monterey?' Doc was having a party, and I guess he had one every night. In spite of his scientific reputation, Doc looked rather eccentric to me with his small goatee. Or maybe he looked like a fisherman with his ragged pullover sweater. Steinbeck informed me with a smile that Doc's real forte was not only marine biology, but also feminine biology.

"It was a rainy night, and the street was unlighted. When we knocked on the paint-peeling door, a group of laughing girls surrounded us. A stunning, long-legged blond kissed Steinbeck several times on the mouth, and he explained, 'She's a student at the Hopkins Marine Station.'

"I really liked Carol, his wife, very much, so I felt surprised at all this. In my eyes she was extremely helpful to him, so I felt disappointed in Steinbeck's behavior. At that time in my life I was a little naive. I didn't think people acted that way.

"The lab, as I remember it after all these years, had Navajo

rugs on the walls and a few paintings by local artists. In the center of the back wall there were shelves with hundreds of neatly filed 78-rpm phonograph records with everything from current jazz to Bach, Vivaldi, and Gregorian chants. A smell of urine almost covered the pervasive smell of formaldehyde.

"Someone left early, an attractive Mexican girl who worked in a neighborhood whorehouse. One of the girls mentioned that she didn't want to miss any early-evening tricks. Another girl ordered a big assortment of Chinese food by phone. There was an ample supply of wine and beer.

"My attention was captured by a strikingly beautiful Chinese girl clad in a black-and-red Mandarin jacket. She was Doc's date for the evening. After midnight John with the blond, and Doc with the Chinese girl disappeared into the two bedrooms. That left me sleeping on an uncomfortable couch with only a Navajo blanket to keep me warm."

The trip and their collaboration worked out well, but it never resulted in the picture book that Bristol had envisioned. "A few weeks later he called me up," said Bristol sadly, "and told me, 'This is too great a story for a photo book. I'm going to write a novel.'" That novel, of course, became *The Grapes of Wrath*.

Was Bristol bitter about Steinbeck? "No," he said. "I was disappointed, but I understood his position. After all, I knew he was a fiction writer."

During his life Bristol did publish six picture books on Asia. When his first wife committed suicide, he became so despondent that he burned many of his negatives. Later he married a Japanese woman and went into the business of building houses. When he started this new career he asked his wife to get rid of all of his pictures. He never knew that his mother-in-law said, "You can't do that with your husband's life work," and she hid them in her own house.

No one thought of any of this until years later, when Bristol's

youngest son, Henri ("He was born when I was sixty."), came home as a junior in high school and announced that he had to write a report on *The Grapes of Wrath*. Bristol told him the story, and his wife confessed about the pictures. They recovered the pictures from the mother-in-law's house in Japan. Since then Bristol has been invited to exhibit his pictures in Georgia, France, Santa Monica, and San Francisco.

Did Bristol and Steinbeck ever meet again? "Yes," said Bristol, "we almost did another book. In November of 1941 *Fortune* magazine asked me to do a story on Canada. I asked Steinbeck to do the writing part, but he said he was busy at the moment. We agreed to meet in Vancouver on December 15. The Japanese bombed Pearl Harbor on December 7, and there was a ban on all pictures. I guess you could say that World War II intervened on that one!"

Leonard McKay, San Jose, California

As an officer at the San Jose Book Collectors Club, it was my duty to obtain monthly speakers for the club. Leonard McKay was a natural selection because of his lifetime involvement with books. His family owned the old and venerable McKay Printing Company in San Jose. Privately, he had become a collector of rare old books, especially those noteworthy because of their bindings and finely etched illustrations. He impressed the club members with his specialized knowledge and generous sharing of his books. When he learned of my interest in Steinbeck, he confided that he had met and interviewed Steinbeck while he was still a high school student.

Of course I was intrigued, so I made an appointment to meet him in his office. In retirement, McKay occupied an office that was part of the family printing company in downtown San Jose. The sign over the door said "Memorabilia." This is the new "company," where he buys and sells old books and other antique memorabilia. He sat across from me behind an old wooden desk surrounded by shelves of old books like the antique telephone directories of early San Jose. Bespectacled and dressed in tweeds, Mr. McKay looked very much like the scholar, writer, and historian that he was—not the successful businessman or the callow youth who flunked high school English that he had been.

He laughed a lot as he told the story of his meeting with the famous Steinbeck. He enjoyed the memory and the retelling of it. But there was sadness, too. He still deeply regretted the loss of that interview—a loss especially severe to an avid book collector like himself.

Since that interview I have done some business with him. He has sold me some old editions of Steinbeck books and beautifully rebound one for me that was in poor condition.

Mr. McKay lived in the world of books and he deeply appreciated Steinbeck's contributions to that world. He admitted that his understanding of how deep that contribution was only came with his own maturity. Through his eyes we gain a glimpse into the old California, a place where a writer like Steinbeck was once greatly resented and misunderstood.

Leonard McKay was a junior at Los Gatos High School when his fierce old English teacher, Miss Mendenhall, ordered the class to do interviews. Feeling inspired, McKay decided to interview that new author, John Steinbeck, who lived high above his own home in the Santa Cruz Mountains.

There was no listed telephone number for Steinbeck, so McKay knew he would just have to show up at Steinbeck's house and take a chance. Because there was the possibility he wouldn't get to see the author, he packed up his collapsible bamboo fly fishing rod and put it in his pocket. He could always go fishing if the interview didn't work out.

It was an era when it was safe to hike all over the hills, so he started his day by hitching a ride down Highway 17, and this is what happened:

"I caught a ride and got off just before Moody Gulch. Then I saw his one-story house. It wasn't fancy, and it was on the old stagecoach road. Two big black dogs came out to meet me, but they were friendly so they escorted me to the front door. A Filipino houseboy appeared at the front door, asked me what I wanted, and let me in."

What was Steinbeck like? "He was tall, very friendly, with piercing eyes," recalled McKay. "He was willing to give me all the time I wanted. What impressed me was his tremendous disappointment that the people in Salinas and in Los Gatos didn't like him. He said they just wouldn't have anything to do with him."

McKay proudly took his interview in to the teacher, who shocked him by tearing it up in front of the class. "My teacher thought Steinbeck was vulgar, and she said to the class, 'This is disgusting.' I was sick that I had no copy of it."

For further punishment she sent him to Mr. Doug Helm, the vice-principal. Was he punished? "No, Mr. Helm just laughed," said McKay. "Miss Mendenhall was well-known for her strictness. She even kept Olivia DeHavilland from becoming class valedictorian by giving her a low grade."

Next McKay wrote an interview with the caretaker of Lupin Lodge, the local nudist colony. Needless to say, Miss Mendenhall tore that up, too. "Finally I interviewed a local insurance man," concludes McKay. "I knew it was time to give up on creativity, but I had to repeat the course anyway."

McKay remembered the tenor of the times: "I had read *Tortilla Flat* and *The Grapes of Wrath* before the interview. There was a great deal of controversy around here at the time. Steinbeck used four-letter words, so people called it dirty writing. It was still the Depression, and there were few jobs. The Okies were taking them away.

"During summers I was a prune picker, so I resented them too. It was not my livelihood, but it was my spending money. Only later did I develop sympathy for them. During World War II I was sent to Fort Sill, Oklahoma, for training, so I guess that was their revenge."

Despite Miss Mendenhall, McKay devoted his life to the world of books. His family started the Smith-McKay Printing Company in San Jose in 1917. He took it over in 1953 and retired

in 1983, turning it over to his son to manage. They did job print-
ing, but McKay said, "Anytime there were extra bucks, I used it for
printing books." He was a local history buff and the author of *A
Postcard History of San Jose*. As a close friend of the historian Clyde
Arbuckle, he acted as editor as well as printer of Arbuckle's *His-
tory of San Jose*.

Not surprisingly, he also became a book collector. He col-
lected fine edge-painted books, Jack London, and John Steinbeck.
I bought a first edition of *The Wayward Bus* from him. As a
Steinbeck collector he said, "There has been a great resurgence of
interest in him during the past fifteen years. Steinbeck gave us a
new view of the common man."

Why had he chosen Steinbeck as a subject for his interview,
anyway? McKay explained that, "I was left-handed, so I felt differ-
ent from the other students. I didn't feel I had to follow the same
track as other people. I thought Steinbeck felt the same way. As
we get older, we live in our memories. My only regret is that I don't
have a copy of that interview."

George Beatty, Los Gatos, California

I felt like I had stepped even farther back into California history when, after meeting Leonard McKay, I met George Beatty. My husband and I had been members of a gourmet dining group for many years, and one of its members, Vince Garrod, was a descendant of one of California's old pioneering families. Because of the unflattering portrait of California growers that Steinbeck presented in The Grapes of Wrath, it took me a long time to mention my Steinbeck interest to Garrod, for fear of offense. Finally I did, and he responded with the hearty graciousness of the frontier. When I asked him if he knew of anyone who had known Steinbeck, he laughed. "You could talk to my cousin George in Los Gatos. He was his neighbor, but he didn't like him much."

Of course, when I met George Beatty he was too much of a gentlemen to mention that dislike. He called the Steinbecks "good neighbors," but I'm sure he used that phrase about every neighbor he ever had. One can read between the lines. I noticed that he had never accepted any of their invitations.

Beatty came down the porch of his old ranch house to greet me. I had driven up an old dirt road off of busy and treacherous Highway 17 to find his place high up in the Santa Cruz Mountains. An old, unharnessed horse came to greet us also.

Cordially Beatty invited me into the house, where he had lived with his mother until her death. The house obviously had been untouched since it was built. It was so old-fashioned that it made me feel as if I had stepped into a time machine, carrying me back to the turn of the century. The land, not the house, was obviously of prime concern to Beatty.

Hospitably, he invited me for a tour of the ranch. We walked around it followed by the horse, which Beatty treated like a dog, talking to him, giving him orders, etc. Beatty had a huge spread and talked of many schemes for it, like the construction of a country club. There were some old shacks on the place, which he had rented out. We dutifully followed him up a hill and were rewarded with a breathtaking view of the entire Santa Clara Valley.

Throughout my interview with Beatty, I could envision the young Steinbecks during their short stay in Los Gatos. They were sociable and loved parties. Some of their farming neighbors probably resented them after the publication of The Grapes of Wrath. Others, like George Beatty, may have just ignored them.

George Beatty remembered when John and Carol Steinbeck suddenly became his neighbors.

"They used to have a house down on Greenwood Road until they moved up here into the Santa Cruz Mountains. You can see it from here. They moved into a beautiful ranch, the old Biddle place, right near Moody Gulch up on Brush Road. It used to be a fruit ranch."

How did he remember them? "They were good neighbors," said Beatty, "and everyone liked them. They were big party people, always having parties. They invited all of the neighbors, but I never went because I would be too tired after a day of ranching or construction work. One of my other neighbors, Frank Raneri, always went, and he said they gave great parties."

Beatty also remembered the image the Steinbecks had around

town. "In 1936 they bought a Dodge convertible, and they used to drive around town with the top down. I just had a Ford, so I thought they were very sporty looking. She was absolutely beautiful."

Sometimes the Steinbecks were mentioned in the social columns of the local paper, but there were no scandals. "They used to drink at the different bars around town, but everyone did. It was a time when everyone liked to drink a lot, but everyone managed to hold their own. There wasn't any harm in it."

At that time the Santa Clara Valley was known as the Valley of Heart's Delight because of the orchards of flowering fruit trees. Many people who "made good later" decided to move to Los Gatos because it was a "live and let live" kind of place, according to Beatty.

In the early days the Lockheeds, of airplane fame, were George Beatty's neighbors. A most memorable neighbor was the famed violinist Yehudi Menuhin. "He hated to give up his place after he gained international fame and couldn't spend time here. He couldn't bear to sell it himself, so he gave it to a real estate man to sell. When it was sold, he didn't want to hear about it until months later."

In Beatty's high school English class at Los Gatos High School, Olivia DeHavilland was his partner. "We used to correct each other's papers. She was first class in every way—brains and looks. I knew her younger sister, Joan Fontaine, too, but not as well. They were arguing even way back then."

Even though the Steinbecks were well-accepted in Los Gatos, Beatty remembered that there was another side to the story: "He knew he could never go back to Watsonville or Salinas. He would have been shot."

Eleanor Ray, Saratoga, California

I first met Eleanor Ray in 1993 at a local author's book-signing at the Saratoga Bookstore in the middle of Saratoga village. Eleanor, frail but still an elegant elderly lady, had just published Vineyards in the Sky, *a memoir-biography of her late husband, the legendary California vintner Martin Ray. At the time I was promoting my own new book,* With Steinbeck in the Sea of Cortez. *Not many customers showed up, so we wound up talking together—and buying and signing each other's books.*

While leafing through the index of Eleanor's book, I noticed Steinbeck's name in an entry. I saw she had actually written quite a bit about the friendship between two couples, John and Carol Steinbeck, and Martin and Elsie Ray.

Elsie, Martin's first wife, died in 1951, Eleanor told me; Eleanor was his second wife. She added that because she had known Martin ever since their college days, and since Elsie later became her good friend too, she had often visited the pair in the late 1930s after they bought famed French vintner Paul Masson's winery and lived at his old vineyard estate in the hills above Saratoga. There she had met Steinbeck, who always called Martin "Rusty," as so many other people (including Eleanor) usually did.

Of course I wanted to know more, so I asked Eleanor's daughter if I could visit their home and talk more about Steinbeck with Eleanor. Barbara Marinacci, a professional book writer and editor, had accompanied her mother to the book-signing; she had also co-authored the book and handled its publication. I arranged to go to Eleanor's home, where Barbara and her husband lived as caretakers of both Eleanor and the family property, in the midst of hillside vineyards.

I drove for about two miles up to their home on a bumpy dirt road off of Mt. Eden Road. Finally, as I came to an open area toward the top of a hill that overlooked the whole Santa Clara Valley, I thought I might be lost. Then in the distance I saw Eleanor and Barbara waving at me from the veranda of a large hacienda-style house that was covered with Boston ivy.

Eleanor was standing next to a big old bronze school bell on a tall stanchion. She wore a colorful hand-knitted outfit in vivid Mexican colors and design, and her abundant silver hair was caught by a bright headband. A dazzling smile beamed from a face with an almost flawless complexion that belied its owner's ninety-one years.

Eleanor told me she had three children from her first marriage, Barbara and twin sons, the latter both scientist-professors. Before marrying Martin Ray she had been a career woman in advertising and public relations. All the while she had functioned as a single parent. In a spirit well ahead of her time, she took a lighthearted approach to the divorcée experience, as reflected in her first book, We Kept Mother Single, *published shortly before her marriage to Rusty Ray in late 1951.*

For the interview, Barbara settled us at a picnic table on the sunny veranda. Before she tactfully withdrew, she brought out all the copies of the Steinbeck editions, signed and unsigned, that the Rays had collected over the years. Though not a complete set of his works, it was impressive.

Eleanor seemed to enjoy the attention of the interview as she reminisced about her husband's friendship with Steinbeck and her own impressions of him. ("Interesting looking," she commented.) Despite

her advanced years, she still exuded the charm and beauty that in the past had made her a renowned hostess. In the 1950s and 60s she and Rusty entertained illustrious wine-lovers from all over the world; they also inspired a number of young people to take up the "good life" of winemaking, and some of them are now well-known vintners.

Afterwards, I took a short walk with Eleanor in the chardonnay vineyard below the house, which Rusty himself had planted—just as he had designed and built their "chateau" home and the large wine cellar below it. She pointed to the southeast, across a small canyon, toward what is now known as the Mountain Winery. This large property, with its old winery, chateau, and vineyards, had once belonged to Paul Masson, and then to Rusty Ray, who bought it from his boyhood idol in 1936. "There's where the Steinbecks used to visit Rusty and Elsie," she said. Then she waved her hand toward the wild vegetation—oak and laurel and madrone trees, scrubby dry chaparral—on the hillsides around us. "And that's what John Steinbeck called 'Rusty Ray country!'"

When we went into the house, Barbara had tea and cakes waiting for us at the dining table in the huge living room. No wonder the Rays could give such large parties! It reminded me somewhat of the great dining hall at Hearst Castle. Later, Barbara brought out her mother's scrapbooks, and in them were newspaper clippings, photos, and letters dating back to the Steinbeck era in Rusty Ray's life.

Barbara told me in an aside that her mother's memory had begun to dim after writing Vineyards in the Sky during the 1980s. She pointed out that the memoir itself had been purposely fictionalized, and was colored by both Eleanor's uncritical love for Rusty Ray as well as her lifelong flair for drama. (Barbara candidly admitted that she had never been fond of her stepfather—though, like many other people, she considered him a charismatic and fascinating "character.")

Barbara also remarked that she had noticed from the sidelines, as we were talking, that Eleanor sometimes assumed Elsie's or even Rusty's identity when telling me about Steinbeck. It might be difficult, too, to

*separate actual truth from the legendary tales that Eleanor had listened
to as Rusty regaled visitors over the years. So no wonder Eleanor seemed
to feel that she had always been around during Steinbeck's visits.*

*Whatever the state of Eleanor Ray's historical and biographical ac-
curacy in both her book and her talk with me, I had already found the
biography a fascinating chronicle of the times. And now I was equally
entranced by my interviewee.*

What was the mutual attraction, I wanted to know, that resulted
in the warm, lasting friendship between Steinbeck and Rusty Ray,
both in their mid-thirties when they first met? John Steinbeck was
an ambitious, hardworking author still on his way to great fame,
and Rusty Ray was a determined vintner who had begun to put
California on the world map by producing high-priced wines,
some comparable in quality to the best French vintages.

"They were both great storytellers," explained Eleanor. "Mar-
tin loved having an audience for his tales about growing up right
here on the western edge of the Santa Clara Valley, about being a
stockbroker before and after the stock market crash, and of course
about all sorts of skullduggery in the wine industry, past and
present."

As for Steinbeck, "He loved talking about his early life in Sali-
nas and the later colorful years on the Monterey Peninsula—his
happiest times, the way he made it sound. But he also loved listen-
ing to other people's stories when they were both good and well
told."

Rusty Ray was an incomparable raconteur. Steinbeck was es-
pecially taken with his stories about Paul Masson, who was a
quirky yet towering character—mixing light and shadow in a way
that made him worthy of appearing in some possible Steinbeck
novel in the future.

In addition to sharing stories, the two shared a love of good
wine. Ray, as the new proprietor of the Paul Masson Champagne

Company, was experimenting with unblended fine varietals—pinot noir, chardonnay, cabernet sauvignon, pinot blanc, and others. Both Ray and Steinbeck favored the first, which they dubbed "lady pinot noir." One night they partook too freely of the lady's favors, Eleanor laughed. "After dinner Elsie found both of them fast asleep on a bed of wildflowers out in the vineyard."

How did they meet? "Well, they were actually neighbors, living just across a canyon from each other," recalled Eleanor. "John had heard about the winery, so he came over to taste some of the wines, and then he introduced himself. He and Rusty found they had a lot in common, and after that John and his wife Carol became regular visitors."

Talking with Eleanor, I could visualize the Steinbecks as they had been, as social friends. Obviously they had a special charm and were fun company. Even at this stage, according to Eleanor, Steinbeck was frank and open about his appreciation for women and wine.

Sometimes the Rays would visit the Steinbecks but not often—because, as Eleanor said, "They just had a small place. And besides, Rusty had the wine. Often they would come over on a Friday afternoon and spend the whole weekend."

This was the period when Steinbeck was writing *The Grapes of Wrath*. He would work until about two in the afternoon and then go over to see the Rays. Sometimes he would read them what he had written that morning. Eleanor still treasures a first edition of that book, inscribed by the author to the Rays with an apt message: "My vintage for yours."

Eleanor also showed me a first-edition copy of Steinbeck's first published novel, *Cup of Gold*. This he had inscribed to Elsie in Spanish, calling her his *copa de oro*—cup of gold. Eleanor remarked about that relationship, "John was very fond of Elsie, who greatly admired his writing. And I guess he always had an eye for the ladies, anyway. He was up at the house and winery a lot of the

time when he lived in this area, which caused something of a scandal in the village. But I don't think anything unseemly ever happened."

Steinbeck, fascinated by the entire winemaking process, would happily take part in whatever needed to be done at Masson's, from pruning the vines in the spring to harvesting them in the fall to doing all sorts of strenuous cellar work alongside Ray.

During the late 30s, Ray was establishing a solid reputation among wine connoisseurs. Elsie's culinary and social skills complemented her husband's wines and stories. Together they hosted many dinners for notable wine-loving guests such as ex-president Herbert Hoover, surviving members of the Russian royal family, and Julian Street, America's supreme gourmet food and wine authority at the time. (Ray's extensive correspondence with Julian Street during that period is now housed at the Princeton University library.)

The Steinbecks usually bypassed these glamorous dinners. "In a sense, John was a loner," Eleanor said. "He liked to enjoy life but didn't want to clutter it up with too many people. He preferred just dining informally with Elsie and Rusty and maybe a few other friends." At times like this Eleanor sometimes joined them.

Occasionally the Steinbecks brought friends of their own to the Ray's place. One of the most colorful and charming visitors was Ed "Doc" Ricketts. Near the rustic chateau was an old bell, much like the one now on Eleanor's veranda. Rusty had given it to Paul Masson in 1933, so that together they could joyfully ring out the end of the thirteen years of Prohibition, which had nearly destroyed America's wine industry. Later the Rays rang the bell to announce the arrival and departure of guests, and when he was around, Doc loved taking over that function.

Steinbeck also introduced Hollywood comedian Charles Chaplin into the charmed circle. "Rusty always liked to describe

the first time Chaplin came up with John, riding in that funny custom-built Ford limousine of his," Eleanor said. Chaplin got so enthusiastic about Ray's wines that he insisted on taking part in the next day's vintage. After a tiring day of grape crushing and pressing, Chaplin insisted on taking command of the turkey roasting in the fireplace rotisserie.

A knowledgeable connoisseur of fine wine, Chaplin became a regular buyer of Masson wines vintaged by Ray. Visitors were intrigued to see signs on casks saying "Reserved for Charlie Chaplin."

What was Carol Steinbeck like, I asked? "She was very nice, but very quiet," Eleanor said, "though she sometimes got steamed up about current social and political issues."

The Steinbecks enjoyed the same things the Rays did—good wine, good cuisine, and good conversation. Often the dinners were followed by music and singing. The storytelling going on between John Steinbeck and Rusty Ray never ceased, but became wilder as the empty wine bottles piled up around them. Steinbeck once showed his appreciation for the friendship by writing a poem to the Rays, which they framed and proudly hung on a bedroom wall. (Alas, some covetous visitor later stole it.)

The connection between the two men lasted through the years despite many changes—Steinbeck's divorce from Carol and his subsequent move to New York, Ray's sale of the Masson property and business to the Seagrams corporation in 1943, and Elsie's death in 1951. "They kept in touch by letter through the years," Eleanor said, "and each wrote intimately about what he was doing, thinking, and feeling." (Unfortunately, a house fire in 1952 destroyed most of Steinbeck's letters to his friend Rusty.) On his infrequent visits to the area, Steinbeck would sometimes stop to visit Rusty; perhaps he even saw the property his friend had bought in 1944 just to the northwest of the Masson vineyards,

where he was developing his own wine estate. Ray found John changed—"very subdued" was how Eleanor put it, adding that he missed John's once-vibrant, booming voice.

John Steinbeck's loyal friendship was especially helpful to Ray in 1955, Eleanor noted, when the vintner launched his fierce "quality control fight," a national campaign waged through the media and his own close contacts with retailers and customers. Ray hoped to embarrass and pressure the California wine industry into establishing and then enforcing higher standards in the making and marketing of wines, by growing more fine varietal grapes and vintaging them unblended, guaranteeing truth in labeling, and starting an appellation-of-origin system similar to France's. Steinbeck, back East, put his old friend Rusty in direct contact with people who were magazine and newspaper editors and publishers. But the other vintners and the powerful Wine Institute were not yet ready for Ray's proposals. A decade later, though, a new generation of winegrowers began following his precepts and example. By 1976, the year of Rusty's death, the wine revolution was showing the world that California, and America, could make superior and even supreme wines.

Before I left, Eleanor and I stood together on the veranda and looked at the spread of cultivated vineyards and wild terrain around us. Most of this mountainous property now belongs to Mount Eden Vineyards, the successful, prestigious winery that Rusty and Eleanor Ray founded in 1960 as a corporation with member-shareholders. Beyond and below us lay the vast valley, its once-bounteous fields and orchards now replaced by factories, shopping malls, and housing. When Ray owned Paul Masson's place, and when he first came to this mountain next to it, this view from above had been very different indeed, Eleanor commented.

I couldn't help but wonder what John Steinbeck would have thought of the transformation from agriculture to "high tech" in

this area he had lived in and loved over a half-century ago, now called Silicon Valley.

Note: The Martin Ray and Eleanor Ray papers, consisting of thousands of letters to and from friends, family members, customers, wine-industry personages, and wine writers, as well as other documents and items, has recently been given by the Ray Family Trust to the Special Collections at Shields Library, the University of California at Davis. Within some of Martin Ray's letters are passages that refer to his friendship with John and Carol Steinbeck.

John S. Baggerly, Los Gatos, California

For years I have enjoyed a weekly column in the Los Gatos Times
Observer *by a local writer named Bob Aldrich. Often I have learned
little facts about Steinbeck from his column because Aldrich, too, is a
Steinbeck aficionado. When my book about the trip to the Sea of Cortez
was published, he generously mentioned it in his column. When I de-
cided to research Steinbeck's life in Los Gatos, I naturally called up Mr.
Aldrich because he had always been so friendly. "Try John Baggerly,"
he advised me. "He even interviewed Steinbeck when he lived here."*

*I found Mr. Baggerly in the phone book, and he cordially invited
me over when he heard my request. He lives in an old Californian home
at the end of a large circular driveway surrounded by old eucalyptus
trees. Like many San Franciscans from previous eras, his family kept
this house as their "summer cottage." When I arrived I found him
pounding away on an ancient Royal typewriter. He, too, writes a
weekly column—mostly historical—for the local paper. Of course, he
assured me that he only did his first drafts on the old typewriter. Later
he transferred his stories to a modern computer downstairs.*

*There were old books everywhere, and Baggerly delighted in taking
down his old Steinbeck editions to show me. He was in his eighties and
was having some eye problems, but that didn't dampen his enthusiasm.*

His only regret was that he didn't have a copy of his Steinbeck interview, but he gave me some sources where I might find it.

Extremely articulate, Baggerly regaled me for hours with the history of Los Gatos and the history of his own family. He was very proud of the long history of his family in the field of journalism and its close association with early California history. He wasn't above sharing some delicious gossip about the Olders and the Hearsts, and he would laugh uproariously at these tidbits.

Throughout his life Steinbeck avoided reporters and disliked interviews. John S. Baggerly, a reporter for the now-defunct Los Gatos General Mail News, was an exception to that rule.

Steinbeck must have respected Baggerly as a fellow journalist to grant him such a frank interview, especially at a time of intense controversy. Of course Steinbeck had been a journalist, too, with his series "The Harvest Gypsies," which served as the background for The Grapes of Wrath. Throughout his life he would return to journalism— during World War II when his columns as a correspondent for the Herald Tribune became Once There Was a War, and later for Newsday, in "Letters to Alicia."

Baggerly's interview is interesting because it shows how, perhaps out of collegial courtesy, Baggerly was cordially received by an already famous Steinbeck at Steinbeck's home, the Biddle Ranch in Los Gatos in 1937.

"When I first saw him, he was like an old dog who had been shot," recalled Baggerly. "He was in great pain from sciatica in his hips and legs, and limping badly. Luckily we had a good general practitioner in town, Dr. Horace Jones, who cured him."

Despite the pain, Steinbeck proudly showed Baggerly around the ranch. "He really wanted me to see the whole thing. We walked up to the mountain spring that fed the pool. I guess the pool was his wife Carol's idea."

When they went inside, Baggerly was in for another surprise.

"I had heard that he was a hard-drinking man, but he offered me buttermilk. He was drinking a lot of it, but maybe it was because he was sick."

What was his general impression of Steinbeck? "He was a big, burly guy," said Baggerly. "I kept thinking about how powerful he looked. He was very frank and straightforward in his conversation."

According to Baggerly, the house was filled from floor to ceiling with books, many of them foreign editions. There wasn't much furniture. "He lived kind of like a hippie and probably slept on the bare floor. No wonder he had sciatica!"

Why was Baggerly so openly received? "I guess he knew that my dad, the editor, was a liberal. At the time he was under a great deal of criticism for writing about a very unpleasant part of California history, the problems that the Okies had in getting food and jobs. He showed what those poor people went through, and he knew that we were sympathetic."

At the time of the interview, a man named Ed Bauer was doing advertising for the *Los Gatos General Mail News.* "He had been at Stanford at the same time as Steinbeck. He remembered Steinbeck writing about the paisanos, the Mexicans, and the Monterey Peninsula in one of their English classes. Steinbeck was writing about what he knew, but the class just laughed at him. An irate young Steinbeck told the class, 'You'll hear about me some day.'"

When Steinbeck first arrived in Los Gatos looking for a peaceful place to write, he was annoyed that people would walk or drive by his first house on Greenwood Lane to catch a glimpse of him. "He had his own way of discouraging gawkers," laughed Baggerly. "He would stand on his front porch and just relieve himself. Finally he moved up to the Biddle Ranch up in the Santa Cruz Mountains for more privacy."

At other times, when Steinbeck's famous Hollywood friends

would visit, the townspeople would ignore them. "I remember that when he and Charlie Chaplin were drinking over at the Hotel Lyndon bar, a huge crowd gathered," said Baggerly. "I guess at first they thought it was for them. Actually, the local folks wanted to see the organ grinder and his monkey who had come down from San Francisco to earn extra money."

According to Baggerly, a more familiar man-about-town was Steinbeck's father-in-law, the San Jose real estate man William Henning. "He used to come over all the time to play golf at La Rinconado Golf Club with our local real estate man Norm Gray."

Steinbeck and Henning disagreed over politics, according to Baggerly, who tells the following story: "Steinbeck was very pro-Roosevelt, and one day he was defending the WPA projects. Henning was ridiculing the program and told Steinbeck that the men were just standing around leaning on shovels. Steinbeck then handed his father-in-law a shovel and said, 'Go ahead. Start shoveling and let's see how long it is before you need a break.'"

Baggerly admitted that sometimes Steinbeck did like to startle people. "My aunt, Cora Older, was the noted journalist who was married to Fremont Older, William Randolph Hearst's chief editorial advisor. They were frequent guests at San Simeon. When Steinbeck wrote that a certain western publisher, and everyone knew he meant Hearst, had 'a mouth like an asshole,' my aunt was really shocked."

During World War II, Baggerly became what he termed a "typewriter soldier." After his graduation from Washington and Lee University in Virginia, he was sent to Iran, where he interviewed several famous people. His own personal favorite Steinbeck book is *Once There Was a War,* and he showed me his well-worn copy. Of all the people who wrote about World War II, Baggerly considered Steinbeck the best. "His stuff is great. He knew how to get right down to what was going on. His descriptions, especially of the battleships, are beautiful."

Baggerly remembered that Steinbeck was always dressed in long, baggy sweaters, and that his wife, Carol, was always driving around town in a touring car. He said sadly, "I guess they didn't make close friends here, because he didn't stop in Los Gatos when he was traveling around writing *Travels with Charley.*"

Although many writers have lived in Los Gatos, "probably because it is the kind of town where people leave you alone," Baggerly liked the recognition that Steinbeck's residency brought to the town. Once the town considered naming a street "Steinbeck Way," but the plan fell through. More recently, Steinbeck's home on Greenwood Lane became the center of a fiery zoning controversy when the current owners attempted to remodel it.

After a lifetime in journalism, Baggerly rates his interview with Steinbeck his all-time favorite, even though it produced almost no reaction in Los Gatos at the time. "My only regret is that I can't meet him and do it again."

Stanford E. Steinbeck, Atherton, California

It seemed to me that the perfect ending for a book of recollections about John Steinbeck would be an interview with a member of his family, which would end the book on an authentic and intimate note.

I was fortunate to find Stanford Steinbeck, John Steinbeck's first cousin, living in Atherton. As I drove out to his home, called Poppy Hill, I wondered what I would find. When Mr. Steinbeck opened the door for me, I was immediately charmed by his graciousness. He ushered me into his bright, cheery kitchen, and we conducted the interview at his kitchen table. I found him to be a very warm, attractive, and gracious gentleman.

Because Stanford Steinbeck has such a bright, active mind, our conversation ranged over a wide variety of topics—himself, alternative heath care, current movies, and travel. Underlying it all was a sense of his pride in being part of the educated and successful Steinbeck clan—a conservative family that is nevertheless big and broad enough to accept the radical vagaries of his cousin John.

Stanford Steinbeck was five years younger than his famous cousin John, but he realized early that John was a storyteller. "John had gone fishing in the Salinas River and had fallen in and developed

pneumonia when he was in his early teens. It almost killed him. I went over to see him during his convalescence. I was amazed at his ability to turn everything that happened to him into a story. He could just cross a street and make up a story about it. So I really wasn't surprised that he became a writer."

There was a lot of visiting back and forth between the two families during Stanford's and John's childhood. Stanford's family lived in Hollister, and John's family lived in Salinas. Stanford explained the connection: "We were first cousins. My grandparents had five sons. My father, Charles Minor, was the oldest son, and John's father, John Ernest, was the youngest in the family. John's parents were just Aunt Ollie and Uncle Ernest to us.

"There was never any doubt that Aunt Ollie was the dominant force in that family, and very capable. She headed up the savings bond drive in Salinas during World War I, and won first place. Her reward was an airplane ride with a local aviator. He started doing all sorts of stunts in the air, but she never said a word because she didn't want anyone to think she was chicken."

In contrast to the capable and gutsy Aunt Ollie, Stanford remembers Uncle Ernest ("I called him that right up to his funeral") as being rather quiet. "He hadn't been in the service, and his opponents were usually war veterans, but he always won the office of county treasurer anyway," he said. "He always got jobs for John at the Spreckles Sugar factory. Although he didn't have that much money, he supported John with monthly checks during his early writing years."

Stanford also felt close to John's sisters. "I just loved Mary, John's younger sister. During my teenage years I was an air-and-water boy at the local service station, so I could borrow cars. I used to take an old broken-down Ford and visit Mary. When I went to Stanford University it was Mary who introduced me to people and had me over for dinner." He is still close to Mary's daughters, who attend his birthday celebration every April.

Stanford remembers Steinbeck's sister Beth as "hospitable and outgoing," but he remembers Esther as very retiring. "She married a wealthy apple grower from Watsonville. Once she had company while I was visiting, and I mentioned that John Steinbeck, the writer, was related to us. After they left, Esther was angry with me. She told me, "We never tell anyone about that!""

From about 1930 until sometime in the early 1940s, Stanford admitted, the two cousins fell out of touch. John was living in New York, and Stanford and his wife were living in Louisville, Kentucky. Then the company Stanford worked for sent him to run its office in Washington, D.C., and contact with his cousin resumed.

"We'd travel to New York quite a bit and dine with John and Gwen at their home on East 72nd Street," recalled Stanford. "I remember there were some Picasso paintings on his walls, and his next-door neighbor was Bob Benchley."

Did he suspect that John and Gwen's marriage was in trouble? "Not in the least," said Stanford, "except for one time. My wife went upstairs to the powder room and was surprised to see some man kissing Gwen. We thought John and Gwen were happy, and my wife and I loved her."

What about John's other wives? "I never met Carol, but I knew her dad, Wilbur. He was a very nice gentleman, old school. Her contributions to John's work were admirable. She deserves a lot of credit. As for Elaine, she deserves credit for getting John to dress up for the Nobel prize award."

Did John ever talk about his writing? "He never talked to me about his books," said Stanford, "but he did talk about the plays and movies. I also remember him saying that Japan paid him the highest royalties, after the USA."

What did Stanford think of John's books? "I've read them all," he said, "and I guess my favorite is *East of Eden*. It's the one that hits home a little. I was all around that territory. Of course, we all thought *The Grapes of Wrath* was the big one.

The next time Stanford met his cousin was in Mexico. He and his wife were moving to San Diego and, because of gas rationing, he took a side trip to Mexico, where gas wasn't rationed.

"It was 1945, and John had gone to Mexico to advise on *The Pearl*. We met him in Cuernavaca, where he had an apartment in a German hotel; but he had moved into a house, so we took over the apartment. We went over to visit and met his first son, Thom, who was only three months old. I didn't see Thom again until two years ago to celebrate John's birthday at the Steinbeck house. Now we see each other occasionally. He's a chip off the old block. He's shorter than his father, but when he puts on that army fatigue hat I could swear I was talking to John.

The last time Stanford spoke to John was just before John's death. It was in May of 1968, when Stanford and his wife drove across the country in preparation for a trip across Canada. When Stanford arrived in New York he couldn't find John's name in the telephone book; unknown to him, John had moved to Sag harbor. Finally he called John's publisher and agent, and finally got John's phone number.

Stanford sadly recalled his last conversation with his cousin: "He was so interested in our trip. He told me to send him a card from Jasper, Canada. When I heard about his death in December, I couldn't believe it."

What did Stanford think of the Steinbeck Museum? "I think it's perfect," he said. "Those lettuce growers who used to hate him did a marvelous job on the museum. It's fabulous." I couldn't have been more thrilled.

Looking back on his association with his cousin John, Stanford Steinbeck said simply, "The Steinbecks were a wonderful family. I would never trade on John's name."

The Steinbecks held a large family reunion in 1982, and Stanford was one of the speakers there. Were there any special tributes to John? "No," laughed Stanford. "To us he's just John."